IMAGES
of America

HELDERBERG
HILLTOWNS

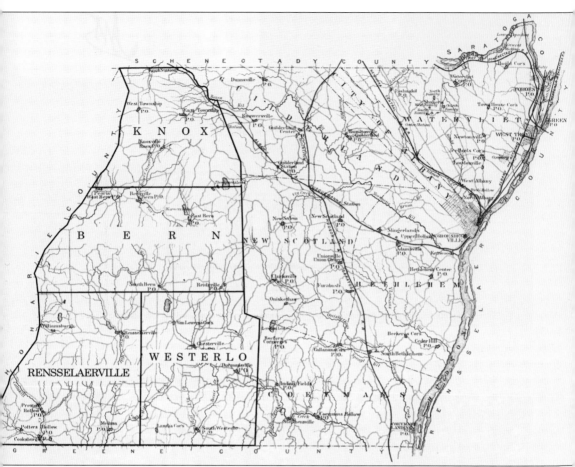

The four Helderberg Hilltowns of Knox, Berne, Rensselaerville, and Westerlo occupy the western portion of Albany County in upstate New York. Their combined area is 227 square miles—42 percent of Albany County—while the combined 2010 population of 10,690 comprises less than four percent of the county. The following images document the shared heritage and unique features of the Helderberg Hilltowns. (Courtesy of Berne Historical Society.)

ON THE COVER: On a summer day in 1895, the Deitz family went for a picnic at Warner's Lake in Berne. The baskets were packed with home-prepared food, glassware, crockery, cloth napkins, and a stoneware jug. The lakes, creeks, ponds, rocky ledges, and rolling hills of the Hilltowns have made ideal picnic spots for generations. (Courtesy of Berne Historical Society.)

IMAGES
of America

HELDERBERG
HILLTOWNS

John K. Elberfeld and Jane B. McLean

ARCADIA
PUBLISHING

Published by Arcadia Publishing
Charleston, South Carolina

Printed in the United States of America

Library of Congress Control Number: 2012931260

For all general information, please contact Arcadia Publishing:
Telephone 843-853-2070
Fax 843-853-0044
E-mail sales@arcadiapublishing.com
For customer service and orders:
Toll-Free 1-888-313-2665

Visit us on the Internet at www.arcadiapublishing.com

This book is dedicated to the residents of the Helderberg Hilltowns.
May you be inspired to preserve the beauty
and heritage of your hometowns.

CONTENTS

ACKNOWLEDGMENTS

We are honored to present this volume in Arcadia Publishing's Images of America series. *Helderberg Hilltowns* became a reality because we received help from so many groups and individuals in the towns of Berne, Knox, Rensselaerville, and Westerlo. There is not enough room to thank everyone, but some contributors stand out. We would like to thank all the members of the Berne Historical Society, Knox Historical Society, Rensselaerville Historical Society, and Westerlo Historical Society for their support and cooperation. Other organizations that deserve thanks include the Albany County Convention & Visitors Bureau, Greater Oneonta Historical Society, Hannay Reels, Helderberg Hilltowns Association, Kiwanis Club of the Helderbergs, New Scotland Historical Association, the three Hilltown libraries, and the four Hilltown museums.

Our fact-checkers verified the accuracy of the book's content. Special recognition goes to Timothy J. Albright, Dennis and Sue Fancher, Willard Osterhout, Russell and Amy Pokorny, the Rensselaerville Research Group, and Barry and Terry Schinnerer.

Special appreciation and gratitude go to the following individuals who offered materials and support for the book: Mary-Jane Snyder Araldi, Ron Barnell, Mary and Charles Bassler, Joyce Bazar, Keith Bennett, Erin Bradt, Robert Brzozowski, Schuyler Bull and the Boomhower family, April Caprio, Barbara Casey, Deb Whipple Degan, Allan Deitz, Marijo Dougherty, Dan Driscoll, Martin Duell, Mitchell Elinson, Jean Forti, Jay Francis, Nancy Scanlon Frueh, Zenie Gladieux, Sarah Avery Gordon, Roger Hannay, Janet Haseley, Edward J. Hogan, Dawn Jordan, Mary Kinnaird, Sandra Kisselback, Catherine Snyder Latham, Helen Lounsbury, Alicia Malanga, Kenneth and Pamela Malcolm, Frances Miller, Hal Miller, Ralph Miller, William H. Moore, Mike Nardacci, Irene Olson, Arthur Palmer, Laura Palmer, Janis Pearson, Robert Peck, Chuck Porter, Jeffrey Quay, Edward Rash, Neil Reznikoff, Jeannette and William Rice, David P. Schanz, Roger Sheely, Kathleen Speck, Kathy Stempel, Sheila and Rudy Stempel, Elizabeth Stevens, Robert Stevens, Travis Stevens, Roland Tozer, Fred Wagner, Homer Warner, Wilma Kelly Warner, Walter Richard Wheeler, Henry A. Whipple, Pauline E. Williman, Whilma and Mike Willsey, and Howard and Kristine Zimmer.

Also, our editors at Arcadia Publishing—Erin L. Vosgien, who helped us start, and Caitrin Cunningham, who helped us finish—deserve special recognition.

INTRODUCTION

The Helderberg Hilltowns are a mountainous region just west of the Hudson River valley and Albany, the capital of New York State. The wild stretches of the Adirondacks are to the north, and Rip Van Winkle's Catskill Mountains are to the south. How did this place, with an area of 227 square miles, come to be?

The story of the Helderberg Hilltowns began 400 million years ago when a shallow inland sea covered the area. Sediment from eroding mountains gradually filled in the sea and left a legacy rich in fossils. Movements of the earth's crust caused upheavals in the topography. The *Helderberg Escarpment Planning Guide* describes upheavals that created the Adirondack Mountains "as if the Earth's crust were being pushed from beneath by a giant fist." This upward movement tilted the layers of rock in the Helderberg plateau toward the south and southwest, creating the landscape of today, with higher elevations in Knox and Berne.

Early Dutch settlers around Albany looked west and clearly saw mountains visible on the horizon; perhaps they also saw layers of light-colored rock along the edge of a cliff. Whatever the reason, they called the cliff "Hellebergh," meaning clear or bright mountain. That cliff is the dramatic Helderberg Escarpment, rising 1,000 feet and forming the boundary between the Hudson River valley and the Helderberg plateau. The four towns atop this escarpment are very hilly and are rightfully called the Hilltowns.

Some say that geology is destiny, and so it seemed as the early pioneers struggled to ascend the forbidding cliff face and extract a living from the rocky, unforgiving wilderness. If geology truly is destiny, then the story of the Helderberg Hilltowns would be one of stone-faced, hard-hearted people facing life's difficulties with gritty determination.

Geology may be responsible for the terrain, but the Hilltowners have shaped their own destinies over the past 260 years. Make no mistake—life in the Helderbergs has its challenges. The weather is harsh, the soil is thin, the water supply is unreliable, and the roads are mountainous and blown with drifted snow in the winter. It is these very challenges that drive the Hilltowners to be strong, to be self-reliant, to be good neighbors, and to be stewards of the land. *Helderberg Hilltowns*, then, is really the story of the lives and times of the people in Berne, Knox, Rensselaerville, and Westerlo.

For centuries, Mahican Native Americans traversed the Helderbergs as they traveled east and west between the Hudson River and Schoharie Creek valleys, or north and south between the Mohawk River and Catskill Creek. They climbed the vertical escarpment using tree trunks, which were carved with handholds and foot notches and placed against the face of the cliff. Early European explorers searching for a northwest passage to the Pacific Ocean encountered Native Americans and established a system of trade; the explorers claimed the land in the name of the sovereigns who financed their voyages. Henry Hudson, sailing for the Dutch East India Company in 1609, opened the way for Dutch colonization along the Hudson River. Agents for Kiliaen Van Rensselaer, an Amsterdam merchant, purchased vast tracts of land from Mahican leaders. This land, called Rensselaerwyck, included the Helderberg region.

Van Rensselaer never left Holland. He and his descendants, the patroons, leased plots of land to people willing to settle on them. After seven years, the tenants were required to pay rent in the form of goods and services. With determination, the tenants faced the backbreaking work of clearing the wilderness and farming the obdurate soil. However, when the tenants learned that they were ensnared in a feudal landlord system and would never be able to buy their land, they rebelled. The Anti-Rent Wars began in the 1840s with a rebellion by thousands of farmers, who eventually gained legal support from the New York Constitutional Convention of 1846, which prohibited future usage of the patroon system.

Who were these embattled farmers who dared risk their lives in defiance of an archaic system? In 1745, several Dutch and German families moving west to Schoharie settled in present-day Knox. Another group moved east from Schoharie, settled near a large beaver dam in present-day Berne, and, by 1765, had established their own church. The threat of danger during the French and Indian War discouraged pioneers from settling the areas to the south (now Rensselaerville and Westerlo). After the Revolutionary War, land leases in the Helderbergs were promised to veterans. People of English and Scottish descent, who traveled from New England and Long Island, joined their Dutch and German neighbors in establishing small hamlets.

The hamlets quickly grew into villages, which broke off from the large Rensselaerwyck town of Watervliet and formed the following four Hilltowns: Rensselaerville (in 1790), Berne (in 1795), Westerlo (in 1815), and Knox (in 1822). Given the broad expanses of land and relative isolation in the Helderbergs, the Hilltowns remained small villages set in farmland. Farmers tamed the forests until the 1850s, when the majority of land was cleared. The main industry was agriculture, and all other enterprises, such as those of the cobbler and the blacksmith, existed to serve the needs of the people who worked the land. Due to the difficulty of traveling long distances, each town aimed to be self-sufficient, providing everything from midwives to undertakers.

The colorful place names tell stories about the Hilltowners and their lives—Beaverdam Road, Beebe Farm, Cheese Hill, Creamery Road, Dutch Settlement, High Point, Irish Hill, Knox Cave, Lobdell Mill Road, Mud Hollow, Murder Lane, Old Stage Road, Pleasant Valley, Ravine Road, Sickle Hill, Skunk's Misery, Still Hill, and Watertrough Road.

This pictorial story of the Helderberg Hilltowns encompasses the era from the 1880s, when photography began to be popular, through the 1950s. It was a time when America was bursting with inventions that changed the way people lived, including the sewing machine, the threshing machine, the telephone, the electric light, and the automobile. These changes affected life in the Hilltowns, too. The Anti-Renters sounded the call of alarm by blowing on their tin dinner horns. When Chester Warner's draft horse was stuck in a barn floorboard, the local telephone operator spread the word by quickly calling neighbors on their phones. For decades, food was kept fresh in iceboxes with blocks of ice cut from ponds; electric refrigerators put an end to the dangerous ice-harvesting operation.

The biggest changes were probably brought about by the automobile. Roads in the Hilltowns were often narrow tracks, mud-clogged in spring and choked with snow in the winter. Automobile drivers demanded improved roadways. As state and county routes were laid down, people could travel around the Hilltowns and, more importantly, off the Hill to find employment. Conversely, people traveling to the Hill discovered the Helderbergs as a vacation haven, a place of peace and respite from city life.

Through three centuries, people in the Hilltowns have made do with what they have, meeting adversity with resourcefulness, ever ready to lend a hand to their neighbors. The following words are from Rudy Stempel's (1929–2012) autobiographical *Memories*: "I am from strong stock; I will persevere and will fight the fight as long as I can. My life was shaped in the Helderberg Mountains of East Berne, by the war, the farm, my family and friends. I appreciate it all. Thank you."

One

THE HELDERBERGS

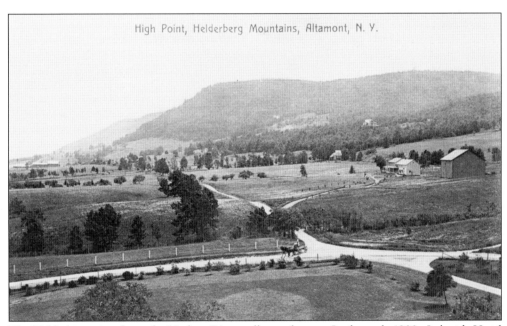

High Point, Helderberg Mountains, Altamont, N. Y.

The Helderbergs rise above the Hudson River valley to the east. In the early 1900s, Lakeside Hotel in Berne attracted visitors with the following description, as documented by the Knox Historical Society: "The Helderberg Mountains stand midway between the Catskills and the Adirondacks and only seventeen miles from Albany. They offer natural scenery which is marvelous to behold . . . The Helderberg caves and crevices aroused the wonder of geologists." (Courtesy of Knox Historical Society.)

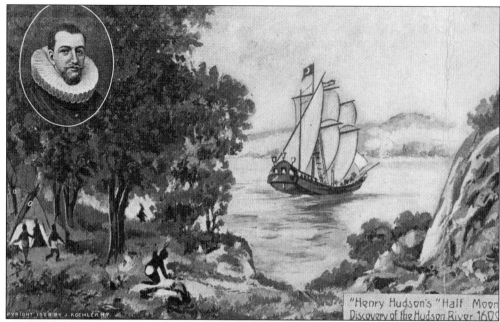

"Henry Hudson's "Half Moon
Discovery of the Hudson River 1609

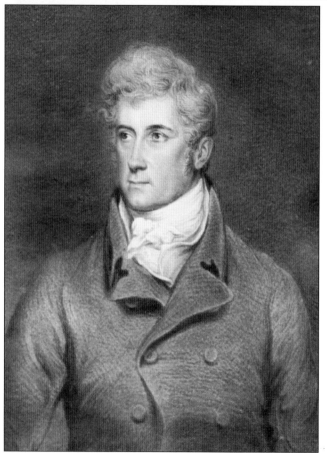

Henry Hudson sailed the *Half Moon* up the Hudson River in 1609 to the present location of Albany, as depicted in this historically inaccurate 1905 postcard. Sailing for the Dutch East India Company, Hudson failed to find the Northwest Passage. Instead, he enabled Dutch claims to the area and set up a thriving fur trade with the Native Americans. (Courtesy of Berne Historical Society.)

In 1629, the Dutch West India Company granted to Kiliaen Van Rensselaer a large tract of land that contained the present-day Albany, Greene, and Rensselaer Counties. Farmers leased land from the patroon, or lord of the manor, and paid a yearly rent. The "Good Patroon," Stephen Van Rensselaer III (1764–1839), pictured at left, did not collect annual payments from the farmer tenants. (Courtesy of Rensselaerville Historical Society.)

Early Dutch colonists called the mountains to the west "Hellebergh," meaning "clear mountain." High cliffs, or an escarpment, separated the fertile Hudson Valley in the east from the Helderberg area. Native Americans scaled the cliff face using tall tree trunks with notched footholds (later known as "Indian ladders"). Pioneers in search of land made their way over the forbidding escarpment with great difficulty. (Courtesy of Knox Historical Society.)

Once the early settlers surmounted the escarpment, they found rolling hills covered with forests. Using simple hand tools, they tamed the wilderness for their fields and farms. Tanners used hemlock bark in their trade, and pillbox manufacturers found the basswood ideal for their products. Today, old stone walls and abandoned apple trees in second-growth forests speak of the hardy souls who once lived there. (Courtesy of Berne Historical Society.)

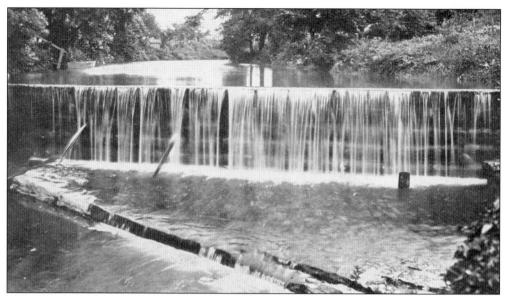

The first settlers in the Helderbergs established their villages near sources of waterpower. The Helderberg Hilltowns were originally part of the town of Watervliet, near Albany. As populations grew, small towns were carved off from the mother town. In 1790, Rensselaerville was incorporated, followed by Berne (in 1795), Westerlo (in 1815), and Knox (in 1822). (Courtesy of Berne Historical Society.)

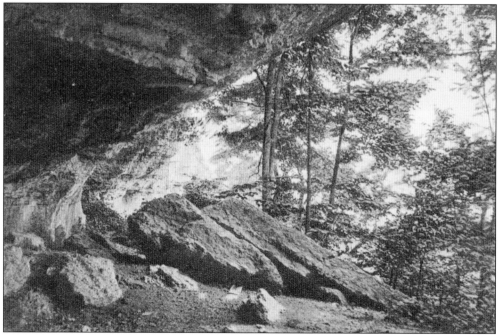

During the Revolutionary War, Hilltown settlers were divided in their loyalties. Patriots sided with the colonists, while Tories supported the crown. Many British loyalists fled to Canada after the defeat of Gen. John Burgoyne in 1777. Local patriots captured loyalist spy Jacob Salisbury at gunpoint when they discovered him hiding in Tory Cave (pictured), as it is now known. (Courtesy of Barry and Terry Schinnerer.)

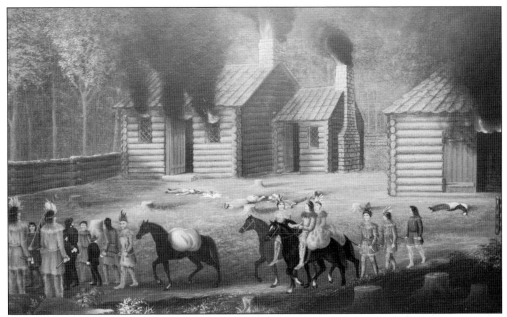

The Revolutionary War did not spare the Helderbergs. In 1781, Native Americans, sympathizing with the British, burned the Beaverdam (Berne) farmstead of Johannes Deitz and murdered eight members of his family. Capt. William Deitz and two young neighbors, Robert and John Brice, were taken prisoner. Captain Deitz died in captivity, but the two boys safely returned home after three years. (Courtesy of Greater Oneonta Historical Society.)

After the Revolutionary War, the patroon promised land rent-free for seven years to settlers willing to develop it into farmland, and many veterans moved west to the Helderbergs. Despite the rocky landscape, harsh weather, and isolation, New England farmers joined Dutch and German settlers in the Hilltowns. Working together, they established villages with sawmills, gristmills, tanneries, blacksmith shops, stores, taverns, churches, and schools. (Courtesy of Timothy J. Albright.)

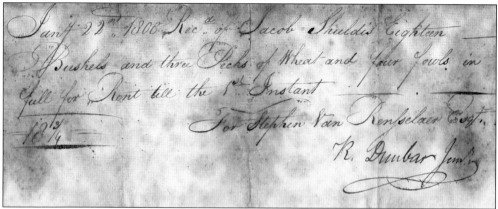

After seven years, the Hilltown farmers were required to pay yearly rent for their land. This receipt reads, "January 22nd, 1808 Received of Jacob Shuldis Eighteen Bushels and three Pecks of wheat and four fowls in full for Rent till the 1st Instant [next year] For Stephen Van Rensselaer Esq. R. Dunbar Junior." Not all farmers could make this in-kind payment, and others refused to do so. (Courtesy of Allan Deitz.)

ATTENTION! ANTI-RENTERS!

AWAKE! AROUSE!

A Meeting of the friends of Equal Rights will

be held on

in the Town of at O'clock.

Let the opponents of Patroonry rally in their strength. A great crisis is approaching. Now is the time to strike. The minions of Patroonry are at work. No time is to be lost. Awake! Arouse! and

Strike 'till the last armed foe expires,
Strike for your altars and your fires—
Strike for the green graves of your sires,
God and your happy homes!

☞ The Meeting will be addressed by PETER FINKLE and other Speakers.

When the Good Patroon, Stephen Van Rensselaer III, died in 1839, his successor refused to compromise with the tenant farmers and attempted to collect all current and past-due rents. Many farmers believed they had signed a lease-to-own contract. When the new patroon made it clear that the farmers could never own the land—and that they could be evicted at any time—they rebelled. (Courtesy of Rensselaerville Historical Society.)

14

The opponents of patroonry joined forces in an anti-rent society, which met in Berne on July 4, 1839. In 1845, 150 delegates—representing thousands of people in 11 counties—deliberated at the Berne Lutheran Church. As a group, they vowed to take action. When the Albany County sheriff attempted to serve eviction notices, he was repelled by bands of farmers threatening violence. (Courtesy of the E.J. Hogan Collection.)

The anti-rent farmers disguised themselves with calico dresses and masks. When an overwhelming militia was called in to support the sheriff, the farmers turned to politics to support their demands. In 1846, the state constitutional convention outlawed the feudal leasehold system of land ownership. However, the patroon still had the right to collect back taxes or to evict tenants. (Courtesy of New Scotland Historical Association.)

Farmers and their families warned each other of approaching law officers by blowing loudly on tin dinner horns. Hundreds of men quickly gathered to head off the sheriff and prevent him from serving eviction notices to their neighbors. The last anti-rent violence occurred in East Berne in the 1880s, more than 40 years after the farmers first united against their oppressors. (Courtesy of Rensselaerville Historical Society.)

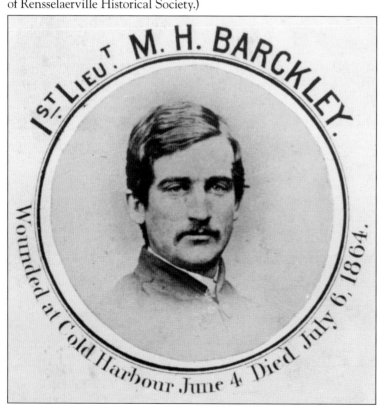

The Civil War had a devastating effect on the Hilltowns. Hundreds of men volunteered for service in the Union army, but many never returned from the battlefields. Lt. Michael H. Barckley recruited 21 of his friends in Knox to enlist in Company K of the New York State 7th Heavy Artillery. Sixteen of those 21, including Barckley, died during the war. (Courtesy of Knox Historical Society.)

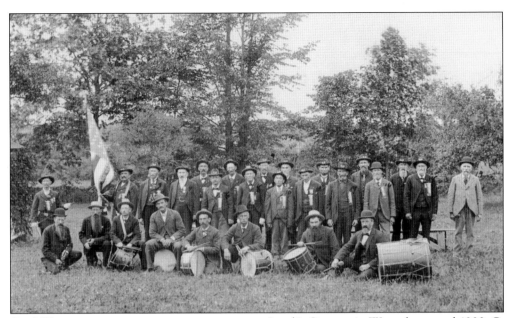

Civil War veterans met in an encampment near Lamb's Corners in Westerlo around 1900. C. Swain Evans died at the Battle of Cold Harbor, and the South Westerlo post of the Grand Army of the Republic (GAR) was named after him. The GAR was a national organization founded in 1866 to support Union veterans of the Civil War. (Courtesy of Westerlo Historical Society and Westerlo Town Museum.)

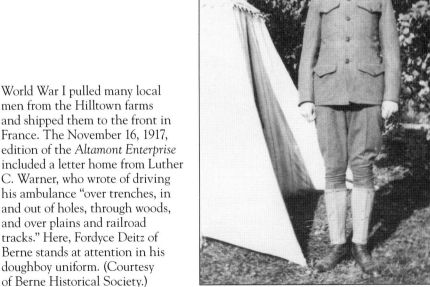

World War I pulled many local men from the Hilltown farms and shipped them to the front in France. The November 16, 1917, edition of the *Altamont Enterprise* included a letter home from Luther C. Warner, who wrote of driving his ambulance "over trenches, in and out of holes, through woods, and over plains and railroad tracks." Here, Fordyce Deitz of Berne stands at attention in his doughboy uniform. (Courtesy of Berne Historical Society.)

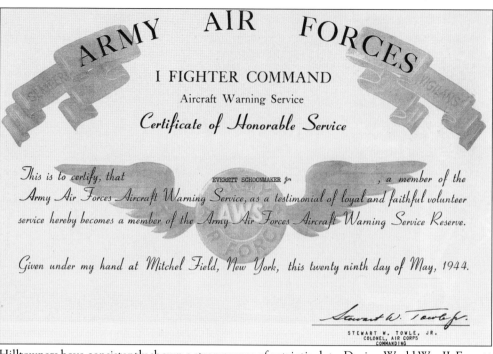

ARMY AIR FORCES

I FIGHTER COMMAND

Aircraft Warning Service

Certificate of Honorable Service

This is to certify, that EVERETT SCHOONMAKER Jr , a member of the Army Air Forces Aircraft Warning Service, as a testimonial of loyal and faithful volunteer service hereby becomes a member of the Army Air Forces Aircraft Warning Service Reserve.

Given under my hand at Mitchel Field, New York, this twenty ninth day of May, 1944.

Stewart W. Towle Jr.

STEWART W. TOWLE, JR.
COLONEL, AIR CORPS
COMMANDING

Hilltowners have consistently shown a strong sense of patriotic duty. During World War II, Everett "Bud" Schoonmaker joined the Berne observation post of the Aircraft Warning Service. He drove high school students to observation posts and received extra gas rations for this duty. The spotters, armed with field glasses and a direct phone line to Albany, staffed the posts 24 hours a day. (Courtesy of Berne Historical Society.)

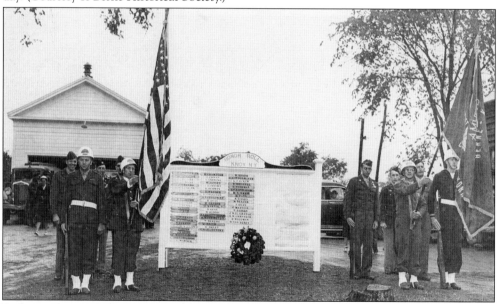

Each town honors its native sons and daughters who serve their country. Men and women from the Hilltowns have bravely served in World War II, the Korean War, the Vietnam War, the Gulf War, the War in Afghanistan, and the Iraq War. In Knox, the World War II Honor Roll was dedicated in front of the old firehouse in the village center. (Courtesy of Berne Historical Society.)

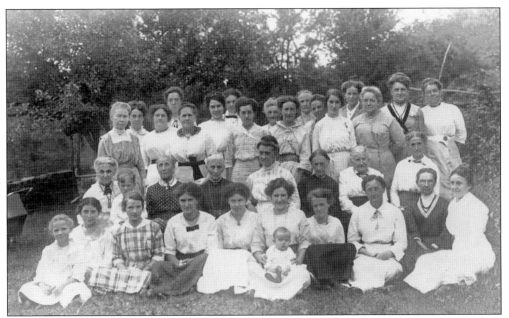

Since the earliest days, people in the Hilltowns have generously given their time and talents back to their communities. The Willing Workers of the Union Christian Church in Medusa are pictured at a gathering in 1916. Like other religious societies, they supported the church and families in need, raising funds for projects with countless church suppers and sales of their handiwork. (Courtesy of William H. Moore.)

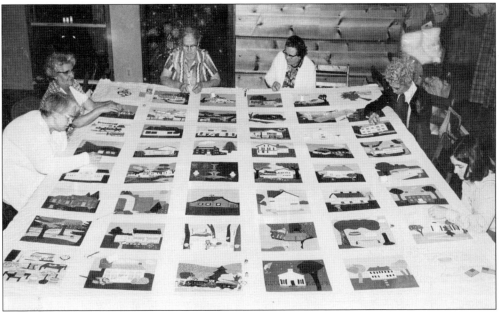

Hilltowners have been invested in the welfare and progress of their towns for over two centuries. They have served as members and leaders of town boards, village committees, boards of education, parent-teacher organizations, fire departments and auxiliaries, church societies, youth groups, and civic organizations. Here, a group of Knox seamstresses stitches the town's history into a quilt. (Courtesy of Knox Historical Society.)

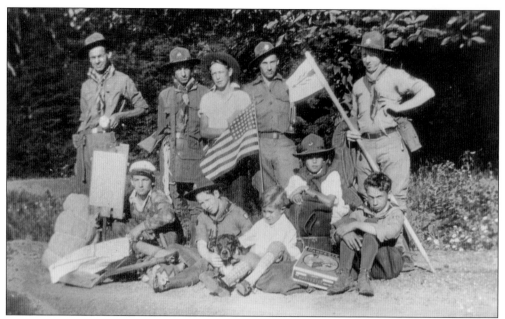

A troop of weary Boy Scouts in Westerlo takes a break with their mascot. Young people learn to be community leaders through organizations such as Boy and Girl Scouts, 4-H, church groups, and athletic teams. These activities would not be possible without the dedication of adult leaders and support of local businesses. (Courtesy of Westerlo Historical Society and Westerlo Town Museum.)

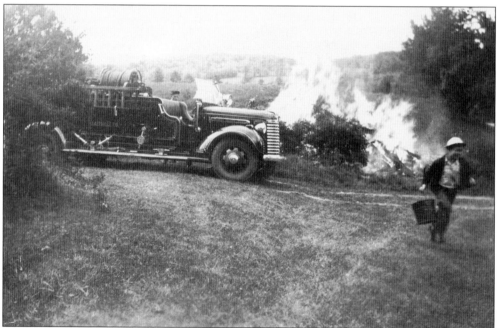

Fires can be heartbreaking events in close-knit towns. The old bucket brigades evolved into modern equipment and fire engines like the Rensselaerville apparatus shown here. Fire departments and auxiliaries in the Hilltowns are staffed by well-trained volunteers ready to spring into action at a moment's notice. (Courtesy of William S. Rice.)

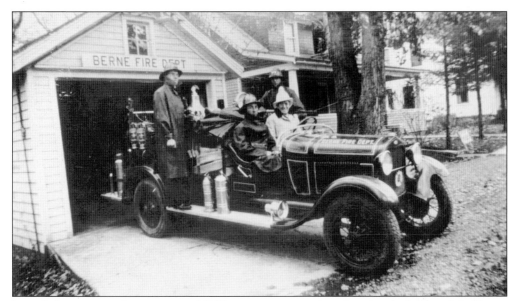

Long before repurposing was a trend, Hilltowners were reusing what they had at hand. In Berne, Edward Filkins had a law office in this small building. In the 1880s, his daughter Carrie Filkins used it for a private school. The building was later a post office and, in 1929, became the first firehouse for the newly formed Berne Volunteer Fire Company. (Courtesy of Berne Historical Society.)

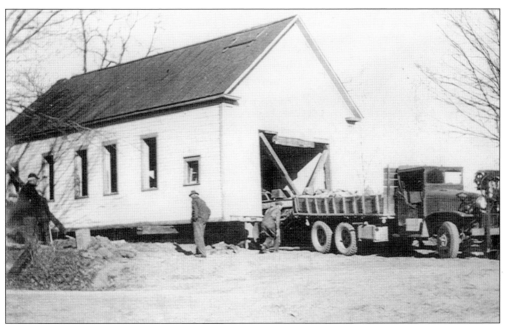

In Rensselaerville, School No. 4 sat on the corner of Main Street and North Road in the hamlet of Medusa. The little one-room schoolhouse served the community until the 1937–1938 school year, when the last student attended as a class of one. The building was moved into the village to be used as a firehouse. The original structure remains inside the present-day fire station. (Courtesy of Medusa Volunteer Fire Company.)

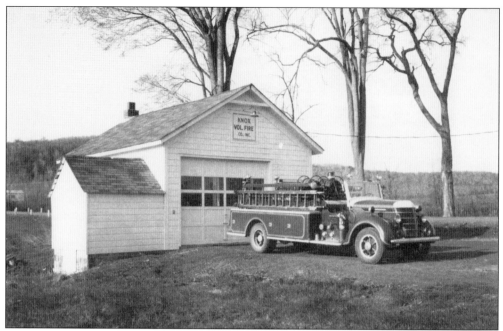

Knox School No. 2 in East Township was built in 1852 for $200. The district dissolved in 1946, and the children were transported to the central school in Berne. Knox Volunteer Fire Company bought the one-room schoolhouse for $1, and volunteers converted it into an auxiliary fire station. (Courtesy of Knox Historical Society.)

Hilltowners believe in the adage of "use it up, wear it out, make it do, or do without." Built in 1887, School No. 17 in Dormansville was vacant after the local children started attending the centralized school in Greenville. Not to be outdone by the other towns, Westerlo also turned a one-room schoolhouse into a fire station. (Courtesy of Dennis and Sue Fancher.)

Two

THE TOWN OF
RENSSELAERVILLE

The town of Rensselaerville was formed from Watervliet in 1790 and originally contained the towns now known as Knox, Berne, and Westerlo. The name was coined to honor the patroon, Van Rensselaer, but also served as a daily reminder that the patroon was the real owner of the land. In 1830, the population was 3,685; in 1930, it was 1,200; in 2010, it was 1,843. (Courtesy of Berne Historical Society.)

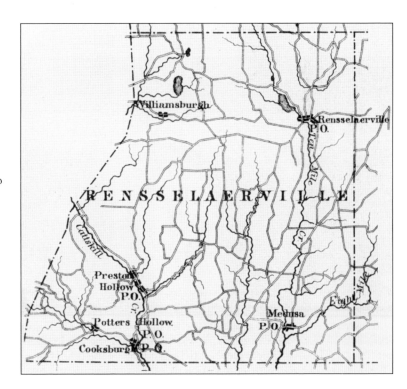

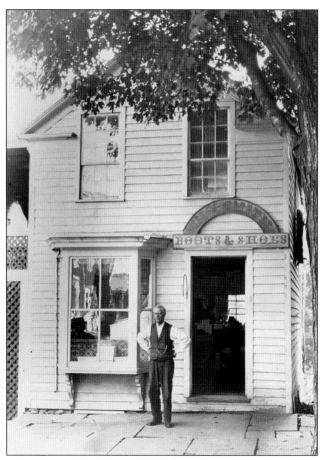

Early pioneers were attracted to Rensselaerville for its abundant waterpower. Many came from New England and Long Island after the Revolutionary War and settled in Cooksburg, Medusa, Potter Hollow, Preston Hollow, Smith's Corners, Williamsburg, and the hamlet of Rensselaerville. The hamlet is now known for its well-preserved historic buildings. (Courtesy of William S. Rice.)

In the 1770s, Dr. Samuel Preston and other adventurers settled on the flats along Catskill Creek in the area now known as Preston Hollow. They built a milldam and sawmill in the dense wilderness. Tanneries used bark from the hemlock forests for processing leather. The village grew, and the Methodist church was constructed on Main Street in 1845. (Courtesy of the E.J. Hogan Collection.)

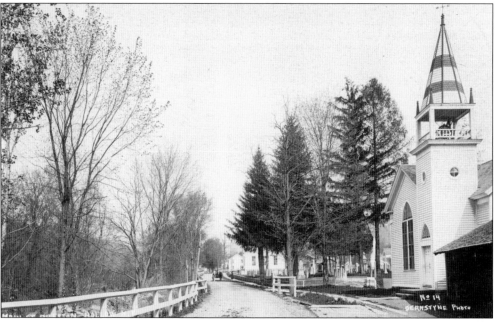

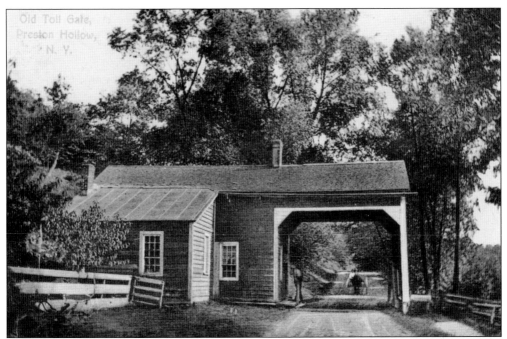

Catskill Creek runs diagonally through the southern section of Rensselaerville. A Native American trail followed the creek valley from the Hudson River through Schoharie County and north to the Mohawk River. The trail became a well-traveled route with a tollhouse (pictured) at Preston Hollow. The toll for this horse and wagon was 6¢. (Courtesy of Rensselaerville Historical Society.)

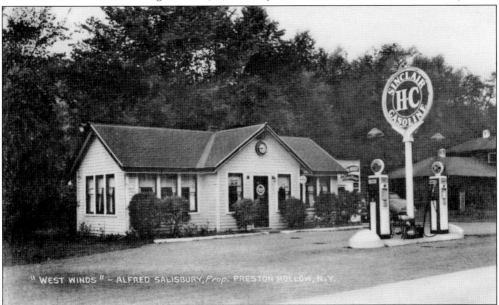

At one time, Preston Hollow had 10 taverns—most of them filled with farmers, animal drovers, and stage drivers and their passengers—within four miles. Daily stagecoaches went from Catskill to Canajoharie, a town on the Mohawk River. Eventually, gasoline engines supplanted horsepower, and roadside filling stations provided fuel for vehicles and a bite to eat for travelers. (Courtesy of Rensselaerville Historical Society.)

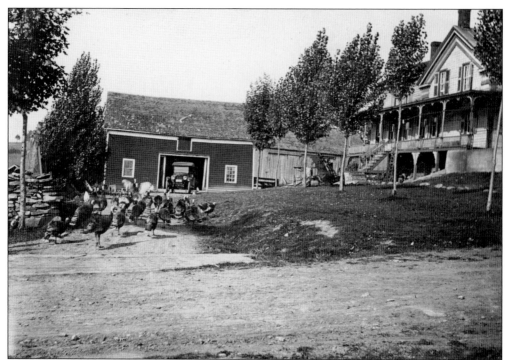

In the early 1900s, Frank and Ellen Haskins ran Fair View Stock Farm high up on windy Cheese Hill in Preston Hollow. They raised purebred, registered, and high-grade Holstein cattle. In 1923, Haskins auctioned the farm "on account of no help and being all worked out," as stated in a notice that was printed in the *Altamont Enterprise* to announce the auction. (Courtesy of Roger Sheely.)

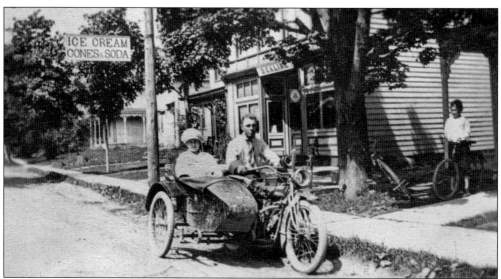

Irving Sheely solicited subscriptions for the newspaper in Albany and rode a motorcycle in the course of his work. He met Dorothy Haskins, daughter of Frank Haskins (of Fair View Stock Farm), and they eventually married. This photograph shows the couple on the main street of Preston Hollow in front of D.C. Kline's store and barbershop. (Courtesy of Roger Sheely.)

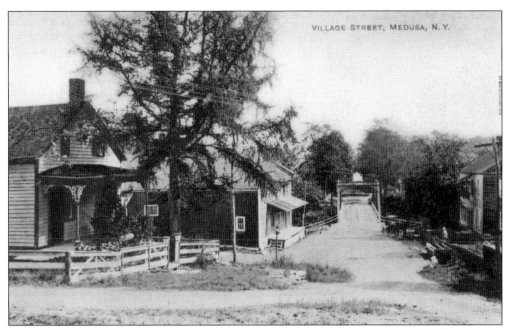

In 1783, Hall's Mills was settled by Uriah Hall and his son Joshua, who built a mill along Ten Mile Creek. In 1850, the name was changed to Medusa to avoid confusion with the town of Hull's Mills. A 1932 fire changed the face of the main street as seven houses, the Methodist church, Goff's store, and Carpenter's garage were destroyed. (Courtesy of William H. Moore.)

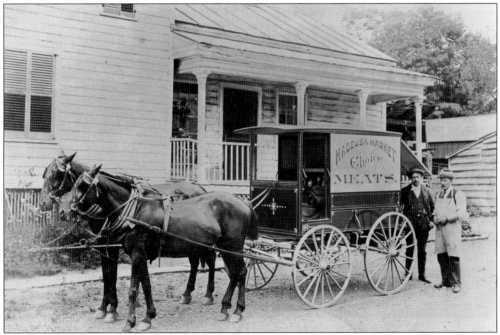

Small shops in Medusa provided groceries, clothing, hardware, and other necessities for the villagers. Hiram "Hype" Fleming was the postmaster and butcher. With the help of his assistant Charles Turk, Fleming delivered meat in this horse-drawn wagon; the sign advertised choice meats from the "Madeusa" Market. (Courtesy of William H. Moore.)

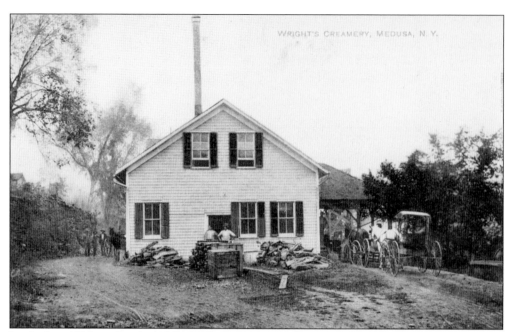

In the late 1800s and early 1900s, Medusa, Preston Hollow, Potter Hollow, and Rensselaerville had creameries. Every day, local farmers hauled milk in 10-gallon cans to be processed into butter or cheese. During World War I, cheese from Italy was unavailable, so Herbert Jennings, the owner of the Medusa creamery, converted it to produce provolone cheese. (Courtesy of William H. Moore.)

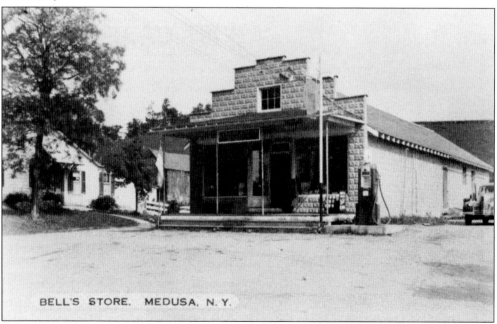

Ernest Bell operated the cooperative store in the Grange Hall in Medusa. He later built his own store, which he ran with his wife, Ruth, where they weighed out bulk products like spaghetti, oatmeal, and sugar. Today, the Medusa General Store, complete with post office inside, carries on the tradition of small-town service. (Courtesy of Rensselaerville Historical Society.)

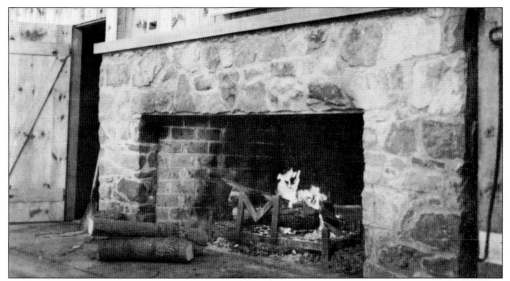

Camp Medusa started as the Young People's Conference of the Congregational Christian Church in 1941. Youth came to Medusa during the last week of June. The boys slept upstairs in the church hall, while the girls stayed with local families. In 1956, a permanent camp was established. The fellowship hall had a kitchen, a dining room, and a large fireplace for communal events. (Courtesy of William H. Moore.)

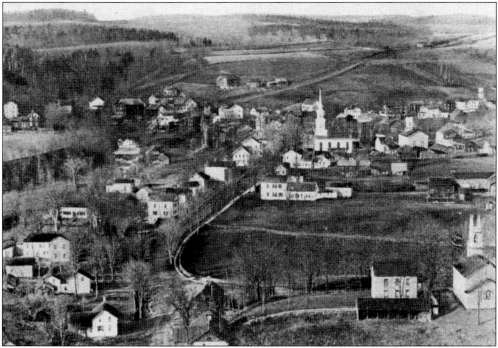

Early settlers in the hamlet of Rensselaerville brought the notion of New England villages with them. Clinton Stone sketched this scene looking west toward the village. In the 1870s, lithograph copies were given away at Huyck's general store with a purchase of $5 in merchandise. In 1984, the hamlet of Rensselaerville was placed in both the State and National Registers of Historic Places. (Courtesy of Rensselaerville Historical Society.)

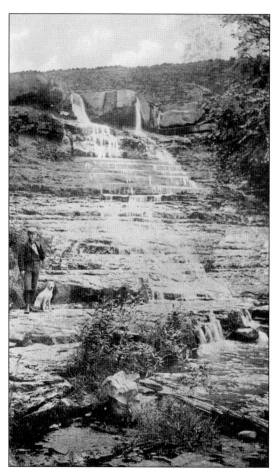

Ten Mile Creek flows through the hamlet of Rensselaerville on its way to Catskill Creek. Samuel Jenkins arrived in 1787 and saw potential for waterpower in the creek and its stunning 100-foot waterfall—he soon built a gristmill. As settlers moved in, other mills sprang up along the waterways, and the village flourished. (Courtesy of Rensselaerville Historical Society.)

Travelers approaching the hamlet from the southwest first saw cleared fields and church steeples, followed by buildings constructed in Federal and Greek Revival styles. In 1843, architect/builder Ephraim Russ completed the Presbyterian church, the spire of which is visible in the below image. It was an elaborate Greek Revival edifice with Doric columns, built of wood but with the appearance of stone. (Courtesy of Rensselaerville Historical Society.)

Trinity Episcopal Church, with its distinctive four-spire steeple, was built by Ephraim Russ and consecrated in 1815. In the mid-1800s, the church ran a parish school just down the hill. Over the years, the congregation updated the sanctuary with a kerosene chandelier, stained-glass windows, an organ with hand bellows, and—in 1931—electricity. (Courtesy of Rensselaerville Historical Society.)

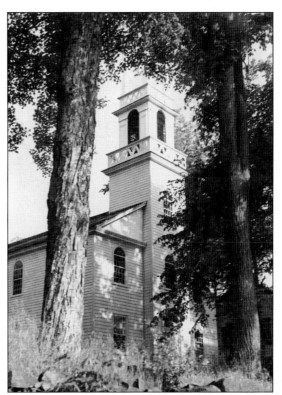

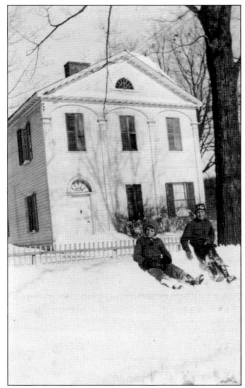

The Greek Revival movement, which flourished from 1820 to 1850, was widely popular in the young United States as a symbol of hard-won democracy. The gable end of the building faced the street, representing a Greek temple. Ephraim Russ built this Greek Revival house in 1823. It has been variously known over the years as the Hutchinson, James Rider, or Waldron House. (Courtesy of Doris Palmer.)

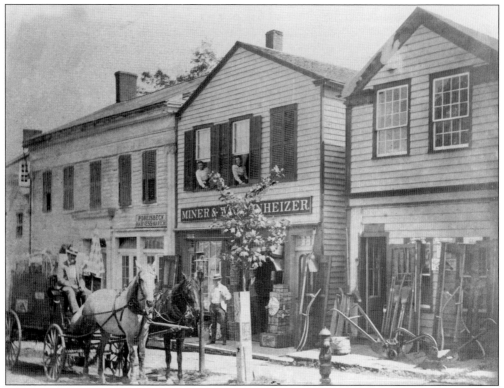

At a time when travel was limited, local shops provided most goods. Henry Miner and Nathaniel Wageonheizer peddled groceries from their wagon and sold hardware at their general store in the hamlet. Harness-maker Phil Dreisbeck had a shop next door. Street lamps and fire hydrants contributed to public safety. (Courtesy of Rensselaerville Historical Society.)

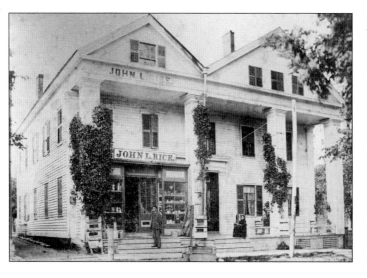

John L. Rice, an early photographer, came to the hamlet in a wagon containing his daguerreotype business. He bought the Union Hotel in the 1860s and became a merchant and postmaster. When paper money was scarce during the Civil War, he issued currency redeemable at his store. His descendants ran the general store for more than a century. (Courtesy of William S. Rice.)

In March 1936, two extraordinarily heavy rainstorms brought floods, which devastated the Northeast from Maine to the Potomac River. Royal S. Copeland, the senior senator from New York, was instrumental in passing the federal Flood Control Act of 1936. Here, William F. Rice Sr. cleans up after flood damage in his general store. (Courtesy of William S. Rice.)

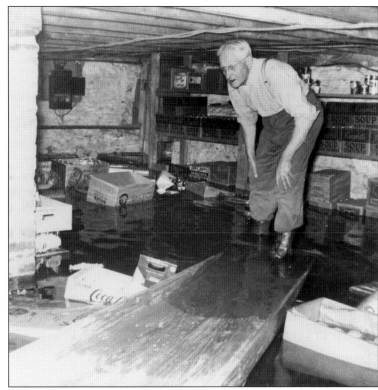

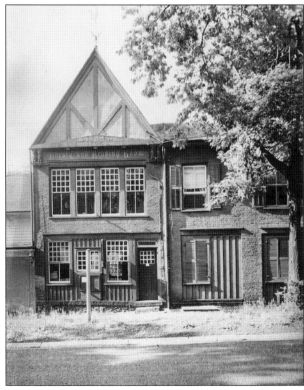

Rensselaerville Library and Reading Room was built around 1820 as one of the row houses on the bank of Ten Mile Creek. In 1906, Francis C. Huyck Sr. purchased and renovated the building, adding the Tudor facade designed by Jacob Becker. The Huyck family donated the building to the community to be used as a library. (Courtesy of Rensselaerville Historical Society.)

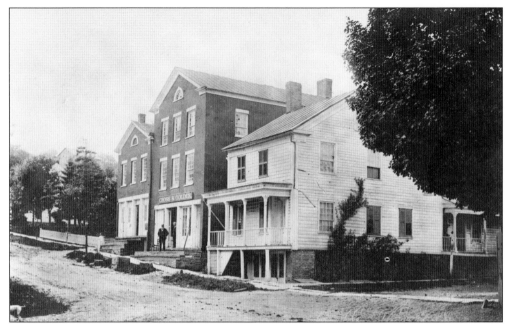

Edmund Niles Huyck owned the two brick buildings (at left in this image) where a narrow lane intersected with Main Street. As motor travel increased, the lane was widened, and Huyck removed the building shown at far left for traffic safety. He also removed the third story of the Cross & Golden Building, shown with two people standing by the door. (Courtesy of William S. Rice.)

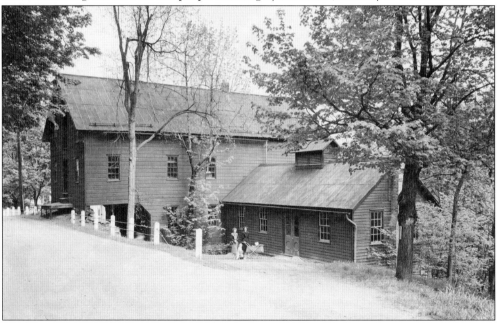

The original gristmill near this site on Ten Mile Creek burned down in 1879. The next year, George Bouton and Francis C. Huyck Sr. rebuilt it as a custom flouring mill. Magdalena Britton (left) and Kathleen Bennett, pictured here, were early members of the Rensselaerville Historical Society, which acquired the mill in 1975 and spent the next five years restoring the mill complex for use as a museum and research room. (Courtesy of Rensselaerville Historical Society.)

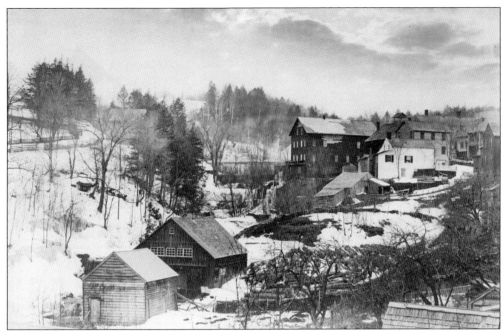

The combination of raw materials, waterpower, ingenuity, and willing hands led to the development of a variety of enterprises in the hamlet. John Shultes was the first owner of this sawmill and cider press (shown in the foreground at left) along Ten Mile Creek. The mill and lumberyard were demolished in the 1930s. The gristmill in the center background is now the Rensselaer Grist Mill (the Rensselaerville Historical Society's museum and research room). (Courtesy of Rensselaerville Historical Society.)

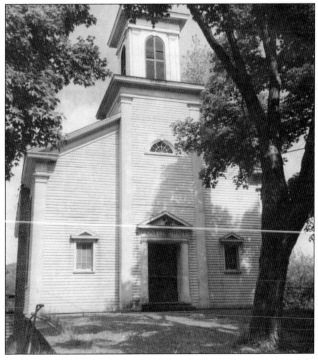

After the Methodist church congregation disbanded, Francis Conkling (F.C.) Huyck Sr. purchased the building and converted it into a community hall. Over the years, Conkling Hall has been a venue for fire engines, oyster suppers, dances, movies, theatrical performances, lectures, Christmas programs, Roman Catholic masses, basketball and volleyball games, graduations, well-baby clinics, cooking classes, and a lunchroom. (Courtesy of Rensselaerville Historical Society.)

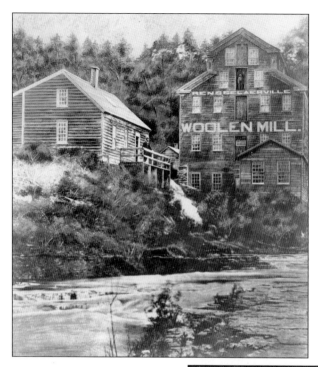

In 1860, Henry Waterbury rebuilt a mill on Ten Mile Creek and installed machinery to process wool. Francis C. Huyck Sr. joined the enterprise, which produced continuous felts for the papermaking industry. Suffering from a labor shortage, a lack of raw materials, and difficulty transporting the felts to market, the partnership dissolved in 1879. Huyck moved closer to Albany to continue the business. (Courtesy of Rensselaerville Historical Society.)

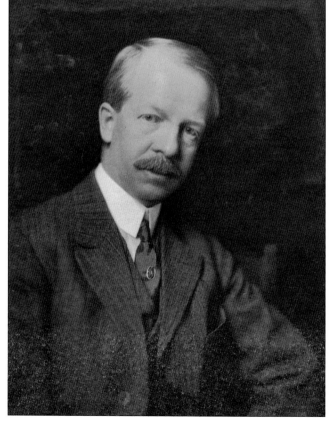

The Huyck family retained its roots in Rensselaerville. E.N. Huyck, the oldest son of F.C. Huyck Sr., cared deeply about preserving the historic buildings in the hamlet. He purchased and restored several village residences. He also encouraged his friends to use the homes as summer dwellings, thus establishing a seasonal community of influential people. (Courtesy of Rensselaerville Historical Society.)

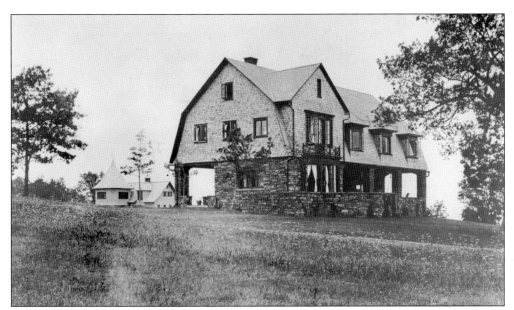

After World War I, Francis C. Huyck Jr. and his wife, Laura Talmage Huyck, united noted leaders and outstanding college students to share a better understanding of the world. The early Country Forums on Human Relations laid the foundation for the Rensselaerville Institute, a not-for-profit educational enterprise established in 1963 on Huyck property. This image features E.N. Huyck's stone-and-shingle summer residence on Pond Hill. (Courtesy of Rensselaerville Historical Society.)

E.N. Huyck purchased the Levi Lincoln farm property in 1912. After his death in 1930, his widow, Jessie Van Antwerp Huyck, established the Edmund Niles Huyck Preserve to protect the natural beauty of Rensselaerville Falls, Lake Myosotis, Lincoln Pond, and the surrounding land. In 1938, she helped found one of the first biological field stations in the country. (Courtesy of Rensselaerville Historical Society.)

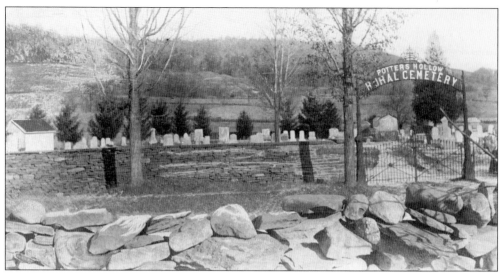

Potter Hollow was settled around 1806 in the southwest corner of Rensselaerville. At various times, the hamlet had a general store, drugstore, sawmill, gristmill, school, post office, candy and tobacco store, barbershop, cabinet maker, hotel, blacksmith, wagon shop, tannery, and cooperative creamery. The Potter Hollow Rural Cemetery is a silent reminder of the villagers who once lived there. (Courtesy of Rensselaerville Historical Society.)

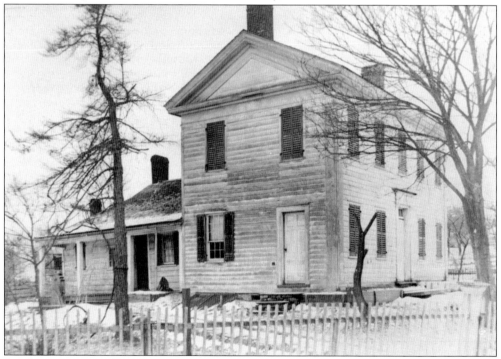

Smith's Corners, in the eastern part of town, was a hamlet named for Moses Smith, a Quaker. The hamlet had a Quaker (Friends) meetinghouse, schoolhouse, cemetery, and blacksmith shop. Isaac Delamater lived in this house and ran a store from the late 1800s to around 1917. Roscoe Delamater, his son, was a local photographer in the early 1900s. (Courtesy of Rensselaerville Historical Society.)

Roscoe Delamater captured beautiful details in this photograph of an old saltbox house in Rensselaerville. A trunk full of his glass negatives was discovered in the attic of his parents' home. The Rensselaerville Historical Society has made great efforts to develop and identify the Delamater negatives. (Courtesy of Rensselaerville Historical Society.)

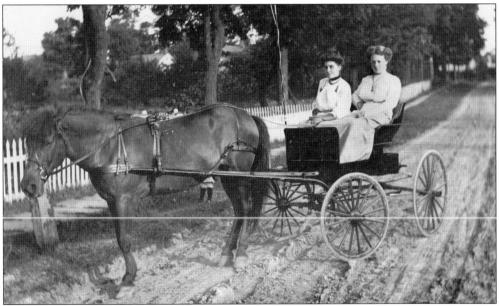

Roscoe Delamater documented small-town life in his photographs of people and places. He positioned this buggy at a three-quarter angle to achieve the best view of two ladies out for a ride. The picket fence and leafy shade, with a scythe hanging in the tree at left, form a pleasing rural background. (Courtesy of Rensselaerville Historical Society.)

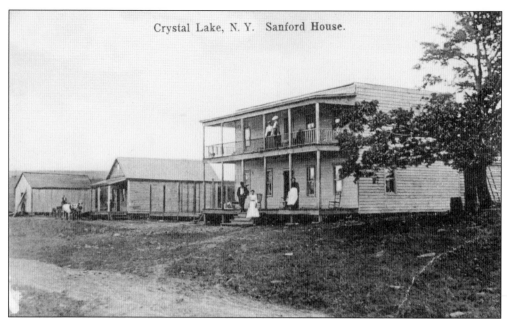

Railway travel opened up the Hilltowns to the growing tourism industry in the last quarter of the 19th century. Visitors traveled by train and made their way by wagon up to Crystal Lake in the northwest corner of Rensselaerville. At the Sanford House, city-dwellers enjoyed farm-fresh food, excursions into the countryside, and cooling breezes from the lake. (Courtesy of William H. Moore.)

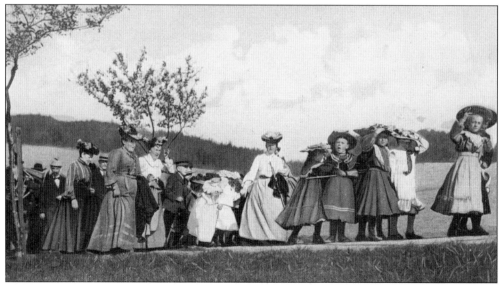

Rensselaerville had several picnic grounds, and every summer, people eagerly looked forward to getting together with their friends. They enjoyed deviled eggs and lemonade, watched ball games, and listened to concerts. This group is wending its way up to Crystal Lake for an outing. The gentleman at far left is carrying a large brass instrument, undoubtedly for musical entertainment. (Courtesy of William H. Moore.)

Elmer Van Tassell delivered the mail in Cooksburg, located on the west branch of Catskill Creek. The hamlet was home to a gristmill, hotel, drugstore, picnic grove, blacksmith shop, flaxworks, and schoolhouse. Cooksburg was named for Thomas B. Cook of Catskill, a railroad businessman. The Catskill & Canajoharie Railroad was expected to go through the hamlet, but the enterprise failed to materialize. (Courtesy of Rensselaerville Historical Society.)

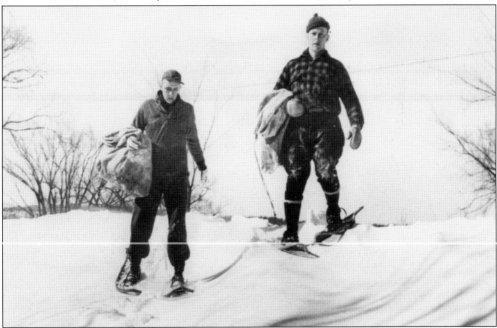

In 1940, Walter Pearson (left) and William F. Rice Jr. trudged 18 miles on snowshoes to take the mail from Rensselaerville to Clarksville. One can only imagine the trek back up this hill with bags full of mail. The training must have been effective, as Rice later became Albany County Sheriff and served in the county legislature. (Courtesy of William S. Rice.)

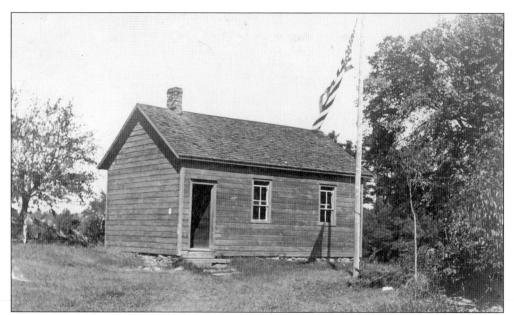

The earliest schools in Rensselaerville were crude log cabins. By the 19th century, the town had public schools, as well as a Quaker boarding school on the Westerlo border and an Episcopal school in the hamlet of Rensselaerville. Some schools were privately owned and did not require standardized teacher credentials. This one-room schoolhouse, located near the Frink home on Gifford Hollow Road, was known as "Frink College." (Courtesy of William S. Rice.)

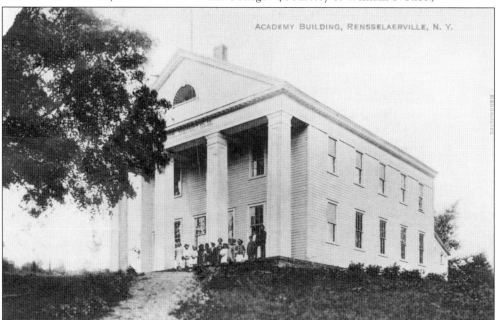

In 1844, the old Presbyterian church, remodeled and with a new Greek Revival front, opened as Rensselaerville Academy (pictured). The school, maintained largely by student tuition, employed two teachers who taught English, classics, and mathematics. The academy had financial difficulties and finally closed in 1898. The students transferred to School District No. 16, Rensselaerville Union Free School, in the same building. (Courtesy of Rensselaerville Historical Society.)

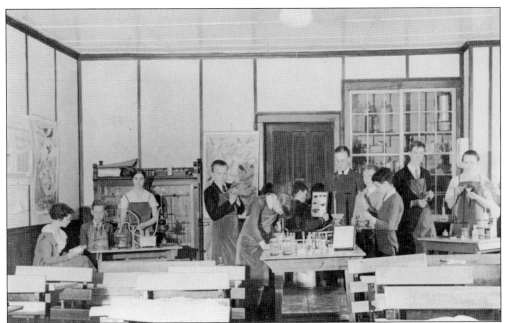

Rensselaerville Union School ("Free" was dropped from the school's name sometime after 1900) had a large classroom downstairs for grades one through six. Grades seven and eight met in the smaller front room. High school classes were held upstairs, where there was a library and a small science laboratory, shown here. Some students boarded with local families during the winter. The old building was razed in 1955, and a new primary school replaced it. (Courtesy of Rensselaerville Historical Society.)

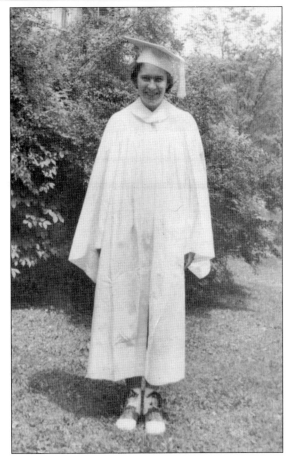

Graduation is an important event in the life of a student. When she graduated in 1939, Doris Boughton looked ahead to the future while remembering her days at school. Boughton participated in the reforestation project that took place in the 1930s, when students at Rensselaerville Union School worked with the state's conservation department to plant thousands of trees in the field above the school. (Courtesy of Doris Palmer.)

Many acres in Rensselaerville were given over to agriculture, with fields of hay and grain, fruit orchards, and vegetable gardens. Farmers raised livestock and poultry, kept bees, and tapped maple trees. During the harvest, people gathered in barns for corn-husking bees, working until late at night and then socializing in the farmhouse over cider and pumpkin pie. (Courtesy of William S. Rice.)

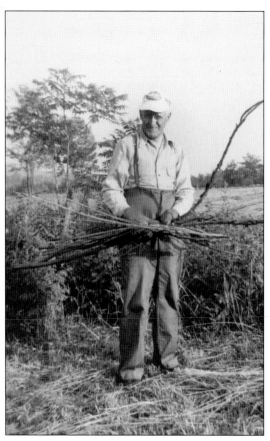

Hops were a thriving business in the late 1800s. The hop vines grew on upright poles. At harvest time, men pulled up the poles and stacked them, while women picked off the blossoms, which were spread out on wire mesh in the upper level of the hops house and dried by a wood fire below. After cooling, men baled the hops for shipment to breweries. (Courtesy of Rensselaerville Historical Society.)

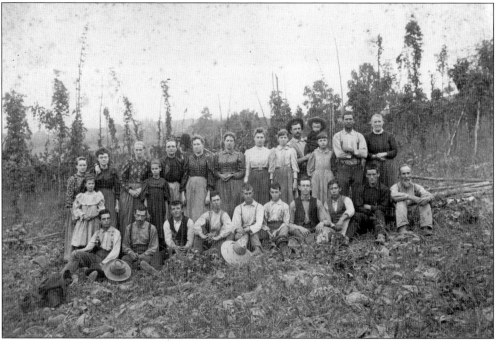

Farm children started helping with chores at an early age—as soon as they could gather eggs. They also brought in firewood and water, weeded the gardens, fed and watered the hens, picked up dropped fruit in the orchards, and brought animals home from the pasture. Here, young William S. Rice is hard at work with his hoe. (Courtesy of William S. Rice.)

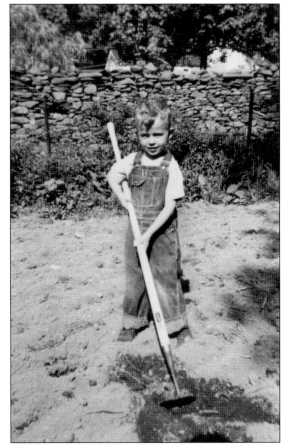

The Rice family has lived in Rensselaerville for generations. This sweet photograph of a baby sitting in the flowers with a watchful dog is among the Rice artifacts but bears no name or date. It serves as a reminder to carefully label photographs and other family treasures so that future generations can know their histories. (Courtesy of William S. Rice.)

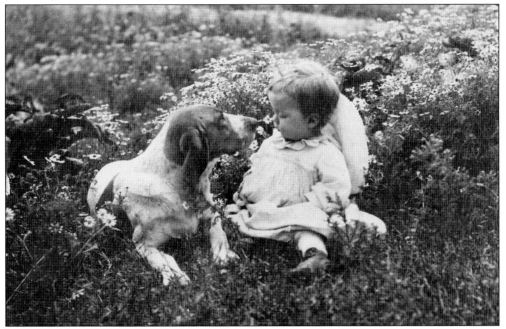

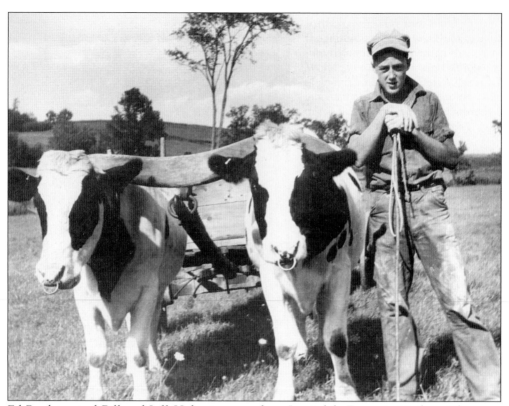

Ed Roulet raised Bill and Jeff, Holstein steers from Lewisdale Farms in Medusa. The oxen provided him with a way of working the land before he could afford a tractor. John Roulet told the Rensselaerville Historical Society that his brother had a special way with oxen, who were the "most trusting, gentle, and cooperative animals you could ever imagine." (Courtesy of Rensselaerville Historical Society.)

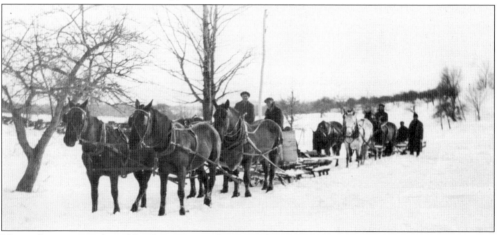

Horse-drawn snowplows like those pictured were replaced by motorized snow removal equipment. On February 15 and 16 of 1958, a massive blizzard hit the Hilltowns. Three weeks later, a 20-man crew finally crashed through the frozen snow near Crystal Lake to reach the farmhouse of 69-year-old Katharine Wood. The self-reliant widow greeted them with coffee and asked what all the fuss was about. (Courtesy of Rensselaerville Historical Society.)

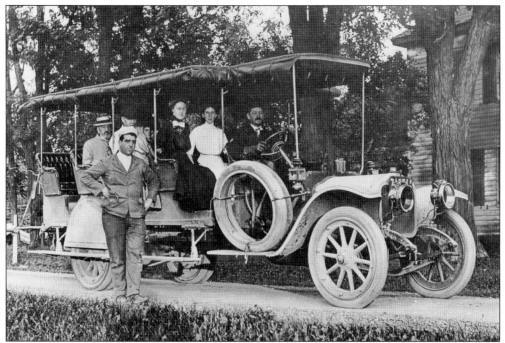

In the early 1900s, Charles Tanner (standing) and Stanton Shufelt (driver) ran a bus line between Rensselaerville and Albany. The bus left Rensselaerville at 7:00 a.m. and went through Medusa, Westerlo, Dormansville, Indian Fields, and Feura Bush. The run ended at the plaza in Albany and returned to Rensselaerville by 4:00 or 5:00 p.m. (Courtesy of Rensselaerville Historical Society.)

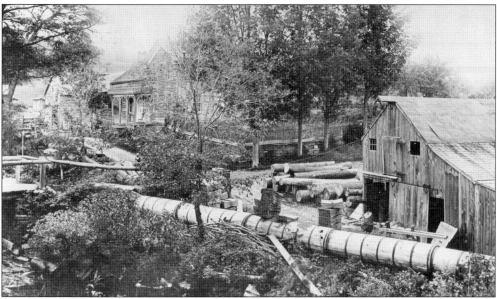

Stanton Shufelt built a water-powered sawmill near his homestead on present-day County Route 6. He sawed lumber, made shingles and lath (narrow strips of straight-grained wood), and pressed apples for cider. The penstock in the foreground carried water downstream from the dam to the mill. (Courtesy of Rensselaerville Historical Society.)

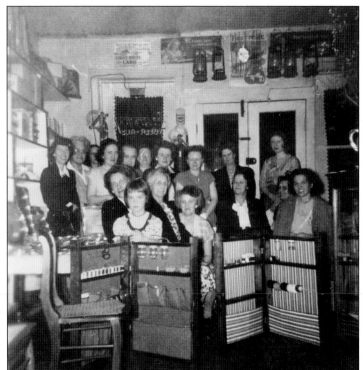

Around 1955, seamstresses of all ages gathered at Rice's general store for this sewing club meeting. The handmade wooden cabinets in the foreground opened like large books and featured thread racks, jars for small items, and pockets for sewing notions. Cabinets like these now fetch a pretty penny at flea markets, antique shops, and in online auctions. (Courtesy of William S. Rice.)

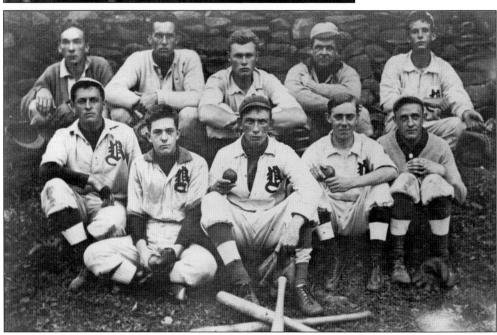

On July 4, 1910, players for the Rensselaerville baseball team proved their mettle in a 2-0 victory over Greenville. Baseball games against local teams were highlights at picnics and village celebrations. On the Fourth of July, citizens rang church bells, listened to orations, and set off fireworks in remembrance of the struggles for independence from both the British crown and the patroons. (Courtesy of the Gordon family.)

Three

THE TOWN OF BERNE

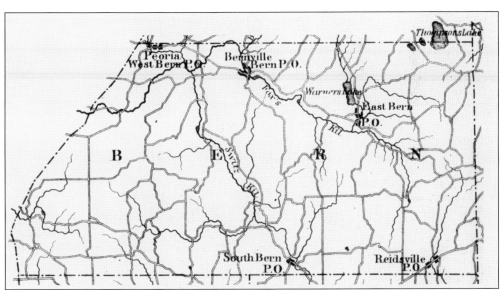

The town of Berne separated from Rensselaerville in 1795 and initially contained the present-day town of Knox. The mountains reminded the Swiss settlers of Bern, the city in their native country, and thus Berne was named. At 2,160 feet, the town contains the highest elevation in Albany County. In 1830, the population was 3,607; in 1930, it was 1,210; in 2010, it was 2,795. (Courtesy of Berne Historical Society.)

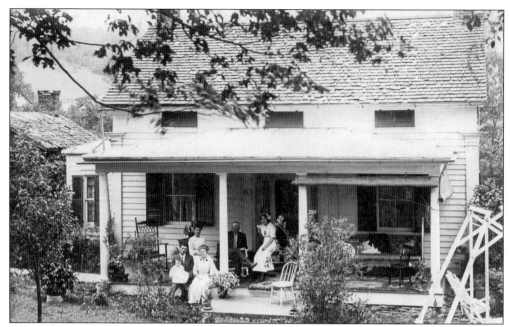

According to *Our Heritage*, "The story of each family is a microcosm of the history of Berne." The Ball family's area history goes back to 1787, when the patroon leased land to three men named Ball. During the Anti-Rent Wars, the Peter Ball family was evicted during a snowstorm. Charles Ball, pictured here in a rocking chair on his porch, farmed at the homestead along the Switzkill. (Courtesy of Berne Historical Society; photograph by P.J. Messer.)

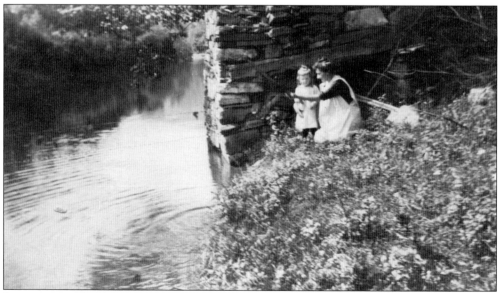

Berne owes its development to Fox Creek, aka the Foxenkill. The creek originates in the eastern part of town, flows through East Berne, and tumbles over rocky, step-like falls in Berne. Joined by the Switzkill, it continues through West Berne and empties into Schoharie Creek. To this day, people delight in throwing sticks into its waters. (Courtesy of Allan Deitz.)

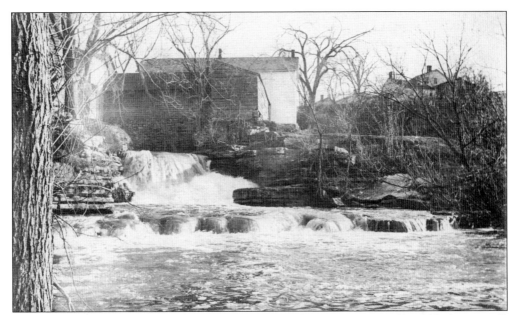

Jacob Weidman built a wooden dam at Berne Falls around 1751 to create a millpond for his sawmill. Soon, a gristmill and a wool-processing mill appeared along the waterway. Aided by the use of a new manufacturing process, the Simmons Axe Factory contributed greatly to the development of Berne, employing 200 men and shipping out 600 axes and other bladed tools each day. All of these enterprises, which were close together on the waterway, used the waterpower provided by the millpond. (Courtesy of Berne Historical Society.)

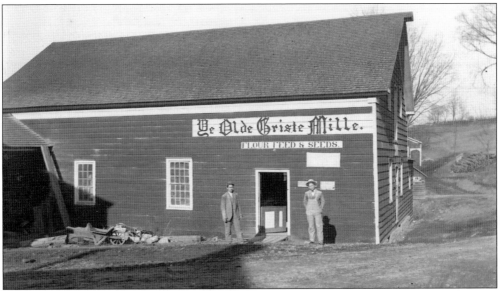

In 1832, Malachi Whipple rebuilt Weidman's mill. In 1920, Frank Hart and his son Milton Sr. purchased the establishment for use as a gristmill, grinding buckwheat flour and feed. The Harts affiliated with the Grange League Federation cooperative (now called Agway) and expanded the business. Milling was discontinued after World War II, and in the 1960s, the Harts dismantled the machinery and donated the millworks to the Rensselaerville Historical Society's gristmill restoration. (Courtesy of Willard Osterhout.)

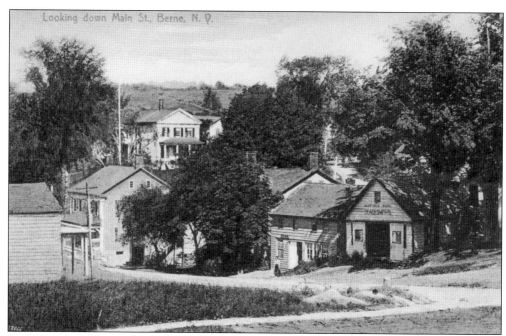

In the hamlet of Berne, heading down to the intersection near the falls, the Lower Hotel (at far left) stood on the corner of Main and Jug Streets (present-day State Routes 443 and 156). The hall at the back of the hotel served as a venue for elections, plays, shows, traveling entertainers, and a circus. The Whipple harness shop (center) and a blacksmith shop (far right) were located next to the hotel. (Courtesy of Willard Osterhout.)

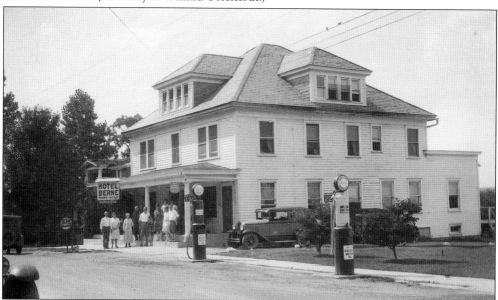

In 1824, Daniel Simmons built the Upper Hotel. The building burned down in the fire of 1914, and Charles Wolford later built this hotel and tavern on the same site. The Hotel Berne (also known as "Berne Hotel" at various times) hosted chicken dinners and had gas pumps outside. In 1960, the town purchased the building—located at 1656 Helderberg Trail—for use as a town hall, library, museum, and center for the Berne Historical Society. (Courtesy of Willard Osterhout.)

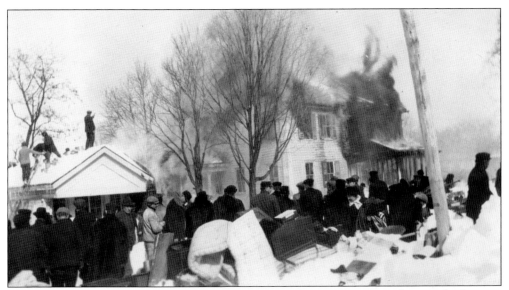

The hamlet had already survived two fires when, in February 1914, hot ashes caught fire in a woodshed on Main Street. The bucket brigade used melted snow to douse the flames, but the fire quickly spread west, burning several stores and homes. People put wet rugs on the roof of a small building to save what would, ironically, become Berne's first firehouse. (Courtesy of the Warner family.)

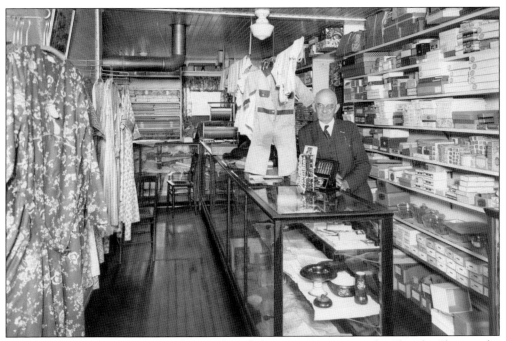

Sisters Florence and Euretha Shultes combined their names to create the Floretha Shop in the hamlet. It was a treat for local women to see what was new in the line of ladies' hats, dresses, and accessories. Frank Shultes, father of the proprietors, stands behind the counter in this 1930 photograph. The building later became Berne's first town library. (Courtesy of Berne Historical Society.)

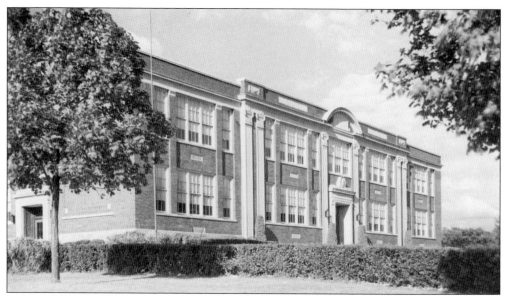

In the 1790s, Berne had two rough log school buildings. In the 19th century, children were educated in a network of one-room schoolhouses throughout the town. The Berne-Knox Central School (now called the Berne-Knox-Westerlo Central School) opened in 1932, and 15 seniors and 20 eighth-graders graduated in 1937. Westerlo joined the school district in 1973, and the school, which now serves students from kindergarten through 12th grade, has expanded over the years to accommodate the growing population. (Courtesy of Berne Historical Society.)

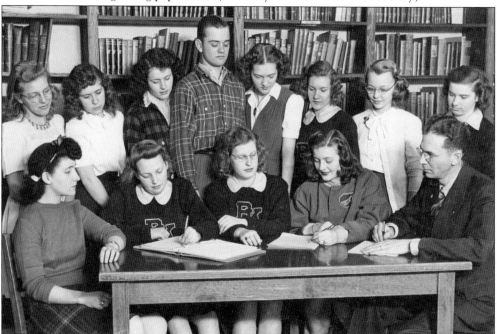

Extracurricular activities have always been part of life at Berne-Knox-Westerlo. The king and queen reigned at the harvest dance, and the school fielded athletic teams, including baseball, basketball, and football. The year's events were recorded in the yearbook. Here, the 1946 Berne-Knox student council meets with principal Walter Schoenborn. (Courtesy of Berne Historical Society.)

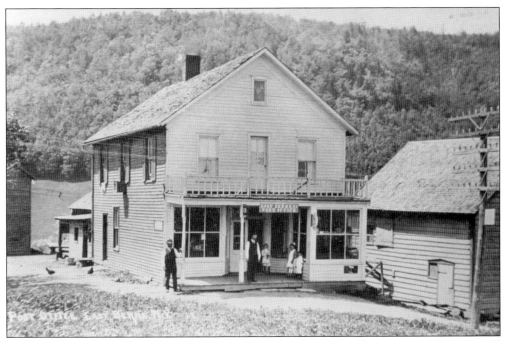

East Berne, situated on the Foxenkill, was a small hamlet with a five-story wooden gristmill and a post office (pictured). In the 1890s, the village looked forward to prosperity when the Albany Construction Company proposed an electric railroad over the Helderbergs from Albany to Schoharie County. The railroad was never built, however, and East Berne retained its rural quality. (Courtesy of Wilma Kelly Warner.)

The students of the East Berne School assembled outside the schoolhouse with their teacher in the spring of 1932. Bob Goetz, one of the children pictured, later remarked on the Albany Hilltowns website that 1932 "was a hard year," hence the unsmiling faces. That fall, these students would join the new Berne-Knox Central School. (Courtesy of Berne Historical Society.)

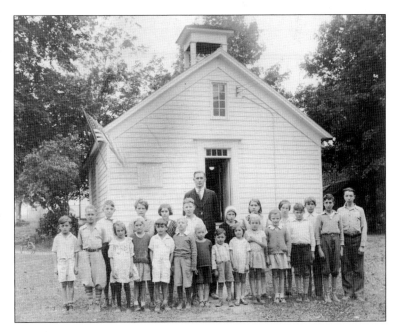

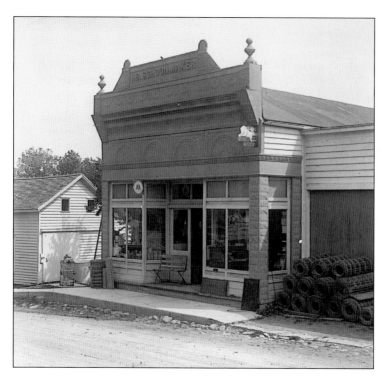

West Berne, formerly known as Mechanicsville or Peoria, lies on the Foxenkill and includes the southwest corner of the town of Knox. A succession of Schoonmakers ran this general store, starting with Dewitt in 1871. Over the years, it had a post office, a public telephone, a gas pump, and a stove where villagers could gather and attempt to solve the problems of the world. (Courtesy of Cheryl Schoonmaker Furman.)

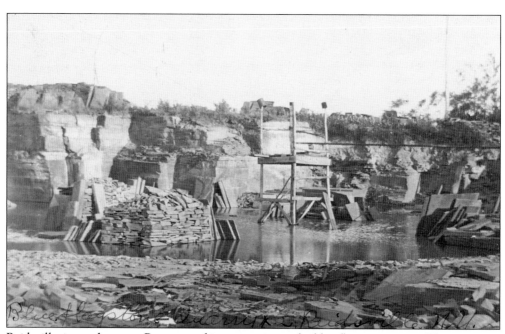

Reidsville, in southeastern Berne, owed its prosperity to the blue flagstone quarry. Bluestone was used in the construction trade for sills, curbing, and sidewalks. The stone was cut and lifted, then loaded onto horse-drawn wagons for a trip down the treacherous mountainside to Albany and destinations as far away as Philadelphia, Pennsylvania. The increasing popularity of concrete was responsible for the decline in this once-robust business. (Courtesy of Timothy J. Albright.)

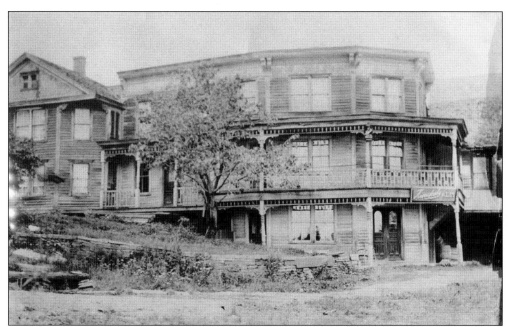

During the quarry's heyday, Reidsville was home to two churches, two hotels, shops, a schoolhouse, and a cemetery. The hotels provided food and lodging for weary stagecoach travelers and beverages for thirsty quarrymen. The Kushuqua was a large inn on Cass Hill Road. At its 1913 Harvest Ball, a couple could get a chicken supper for $1 and then spend the evening dancing. (Courtesy of Berne Historical Society.)

Huntersland is a community in western Berne and eastern Middleburgh in Schoharie County. The Huntersland Christian Church had an evangelical congregation, which held baptisms in the millpond across the road. Children from both towns attended the one-room schoolhouse on the Middleburgh side of the county line. (Courtesy of Berne Historical Society.)

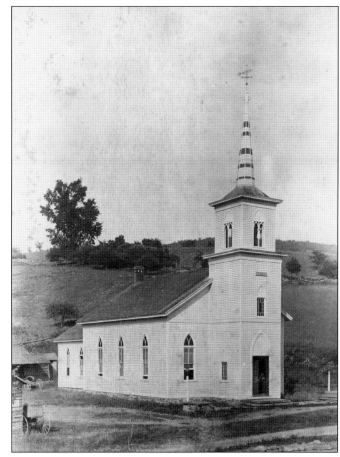

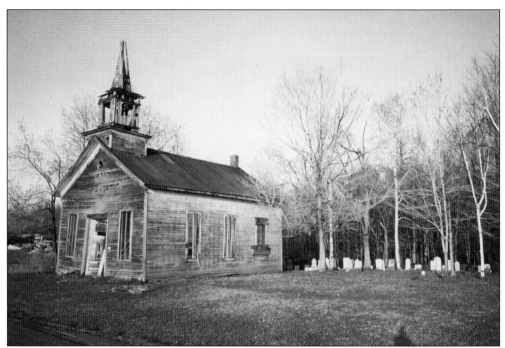

West Mountain, in the southwest part of Berne, contains rugged terrain and the highest elevations in Albany County. In the days before snowplows, the roads were often blocked with snow. When the isolated farm families could get out, they found community at the one-room schools and the Methodist Episcopal church. (Courtesy of Berne Historical Society.)

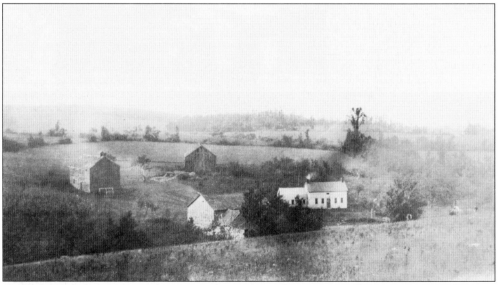

Farms in West Mountain were prosperous during the 19th century. By the 1930s, severe soil erosion and deforestation led to the federal Resettlement Administration buying much of the farmland and relocating the families. The Civilian Conservation Corps then planted many acres of trees on the government-owned land. Today, this land—part of the Partridge Run Wildlife Management Area—is managed by the New York State Department of Environmental Conservation. (Courtesy of Catherine Snyder Latham and the Messer/Snyder family.)

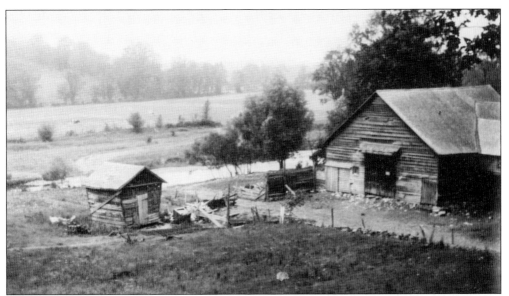

The New World Dutch barn at right, which was located on the Ball-Wright farm, was built in a style popular across the New York and New Jersey region in the pre-industrial era. The boxy building, with its low, sloping roof, was ideal for housing animals, threshing grain, and storing hay and grain. Wagons used the large central double doors, while animals entered through the gable-end side doors, allowing the threshing floor to remain clean. Several of these barns, which are rare historic treasures, are still standing in the Hilltowns. (Courtesy of Allan Deitz.)

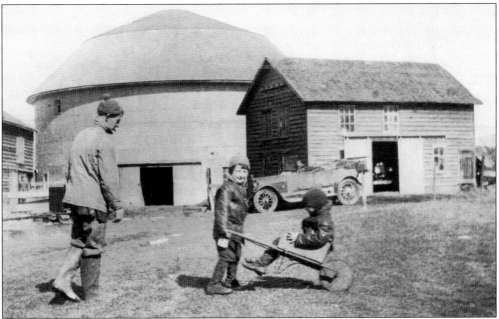

In 1912, after five years of planning, Archie Willsey and his father began building a round dairy barn on Sickle Hill. The barn was 60 feet in diameter and 60 feet in height, with basswood siding covered by galvanized sheets. Here, Willsey watches his daughter Janis push her brother Morris in their handmade wheelbarrow. The round barn burned to the ground in the 1970s. (Courtesy of Janis Pearson.)

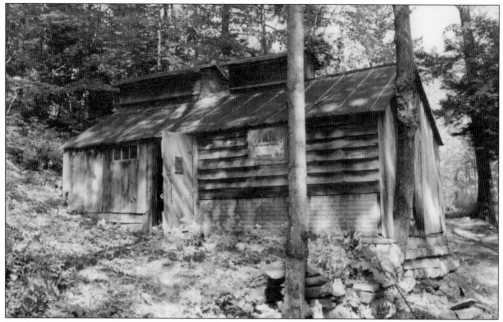

Native Americans collected maple sap in hollowed-out logs and boiled the sap by dropping white-hot stones into it. They shared the secrets of making maple sugar with early European settlers. In the Hilltowns, the settlers first made maple sugar for their own use. With improved equipment such as the sugarhouse and its large evaporator, farmers could produce enough maple sugar and syrup to take some to market. (Courtesy of Janis Pearson.)

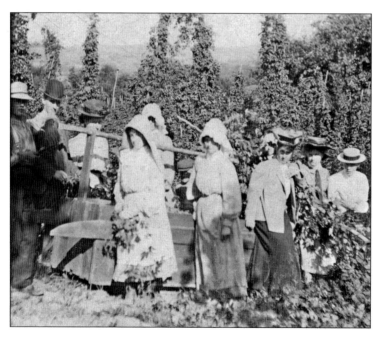

Hops were an important cash crop in Berne. In the 1850s, New York State produced 85 percent of all the hops for breweries in America. The harvest in late summer was eagerly awaited, and city people traveled to the country for a kind of paid vacation. Barn dances were held in the evenings, and many young people held hopes of meeting someone special. (Courtesy of Allan Deitz.)

Camille Gallup earned her teaching certificate at Oneonta and taught in one-room schoolhouses near East Berne. She started her career walking to school, then drove a horse and buggy, and then rode a bicycle. She was one of the first local women to drive an automobile. Gallup is at right in this photograph, possibly with a summer boarder, at what is now Newcombs Farm. (Courtesy of Wilma Kelly Warner.)

Mapleridge Farm on the Switzkill was the setting for this 1925 Ball family reunion. This photograph is a Hilltown Who's Who, with many members descended from the old families. Names like Deitz, Dietz, Gibbs, Haverly, Onderdonk, Schoonmaker, Sholtes, Willsey, and Wright would have been familiar to the adults in the group. (Courtesy of Mike and Whilma Willsey.)

Not everyone in Berne was descended from the founding fathers. The families of Irene Haluska (left) and Teriza Stempel came from Czechoslovakia and took up farming in East Berne. Stempel's son Rudolph Valentino Stempel could not wait to shake the farmyard from his boots. After serving in Korea, he and his wife, Sheila, raised a family and ran a sawmill famous for its rough-cut lumber. (Courtesy of Rudy Stempel.)

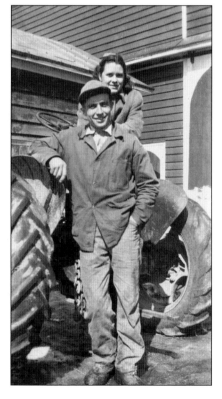

Whilma Wolford was raised on a farm near the Knox-Wright town line. Warren "Mike" Willsey grew up on his family's farm on Stage Road in East Berne. They both attended the Berne-Knox School, eventually got married, and raised their five children on the Willsey farm. Their children continued the farming tradition, showing sheep and calves at the Altamont Fair. (Courtesy of Mike and Whilma Willsey.)

Haying is hot, dusty work and is dependent on warm, dry weather. Whilma Wolford and her brother Herbert used to hope for rainy days so they would not have to help with haying. Whilma's son, a very young Warren Willsey, looked forward to the day when he could really drive the big orange Allis-Chalmers tractor. (Courtesy of Mike and Whilma Willsey.)

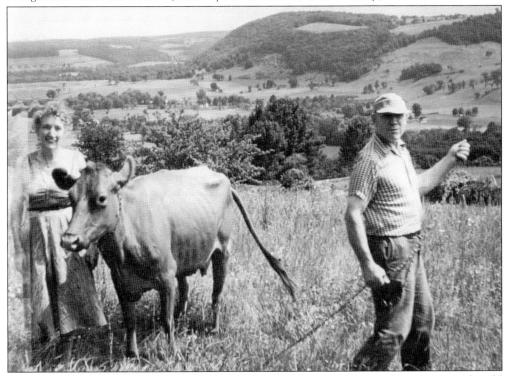

On a summer day, Myrtle and Ivan Schanz led Rosie the cow out into the pasture at the old Shultes farm on Sickle Hill. A look over Ivan's shoulder gives the reader an unforgettable view of the hills and valleys in the western section of Berne. (Courtesy of David P. Schanz.)

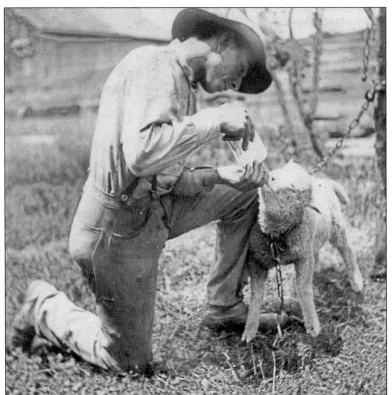

After a long winter, the arrival of spring lambs was a happy event. In the pioneer days, women laboriously carded the wool by hand to prepare it for spinning. A carding mill was built on the Foxenkill around 1797; the mill could card as much wool in an hour as one person could produce in a day. (Courtesy of Berne Historical Society.)

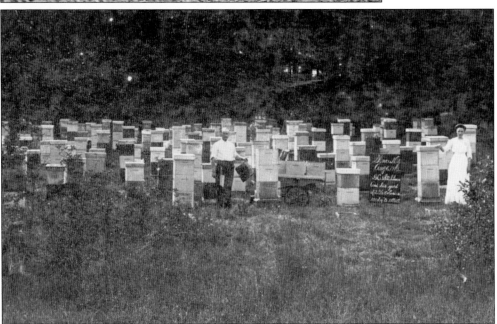

This beekeeper used hives with movable frames so that he could inspect the hives without disturbing the colony and gently extract the honey without damaging the combs. Farmers often planted certain crops, such as buckwheat, near the hives to provide nectar for the bees, who in turn produced honey with distinctive flavors. (Courtesy of the E.J. Hogan Collection.)

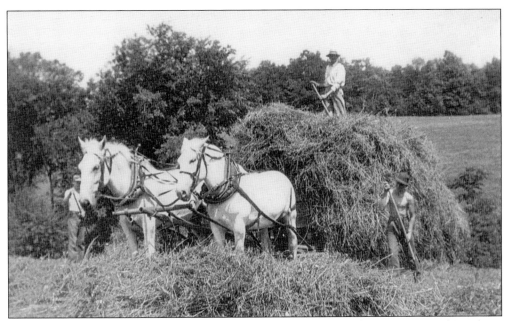

Jerry (left) and Molly were Percheron draft horses at Camille and Chester Warner's farm above Warner's Lake. Molly's leg once went through a board in the barn floor; someone called the local telephone operator, who swiftly rounded up neighbors to help lift the horse. In the days before 9-1-1, quick thinking and willing hands saved the day. (Courtesy of Homer Warner.)

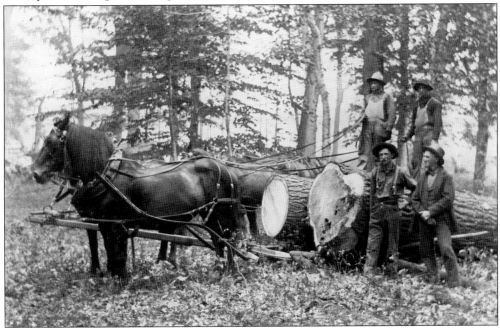

Logging was a big business in the Hilltowns. Tanneries cured leather with tannin from hemlock bark, while basswood trees in Knox supplied the basswood pillbox industry. Each town had at least one sawmill along a creek. Furniture, household items, and tools were made of wood, and the growing communities in the Hudson River valley demanded thousands of board feet of lumber for housing construction. (Courtesy of Willard Osterhout.)

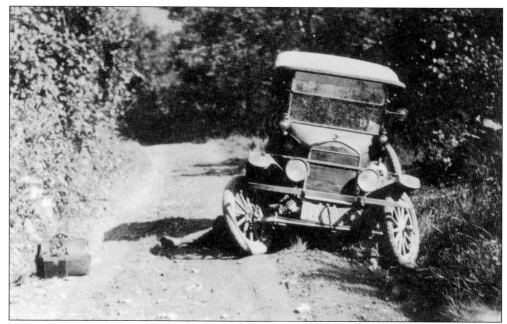

Berne is notorious for its challenging roads, which were carved out of rocky terrain and have narrow shoulders, hairpin turns, steep hills, and a double-S curve (on the road heading north toward Knox). This West Mountain driver (whose legs are visible in the center of the image), far from a service station, tried valiantly to get back on the road. (Courtesy of Catherine Snyder Latham and the Messer/Snyder family.)

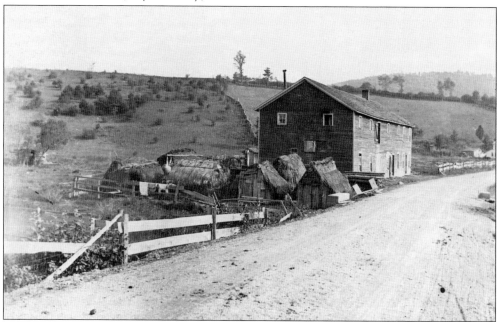

The thatch-roofed huts next to the old cheese factory housed Italian laborers who worked on the state road. The many miles of steep and winding roads in Berne are subject to flooding, blizzards, frost heaves, and other acts of nature. Town, county, and state crews keep the roads in excellent condition year-round. (Courtesy of Willard Osterhout.)

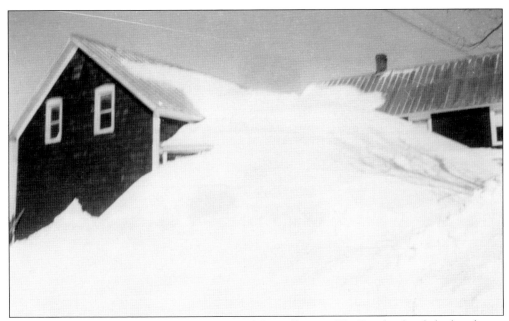

On February 14 and 15, 1958, a blizzard battered the Hilltowns. The Remley family had to ski out of the second-story windows of this snowbound house. Twenty-foot drifts closed the roads. US Army helicopters flew in with food and evacuated people who were ill. The National Guard, in single-engine planes, airdropped 90-pound relief packages to isolated families, who marked drop zones with a big "X" made of lumber. (Courtesy of Howard and Kristine Zimmer.)

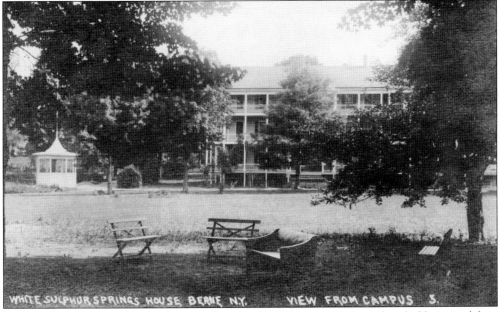

In the 19th century, vacationers began to discover the Hilltowns. They sought relief from city life in fresh mountain air and through the medicinal properties of mineral waters. Jacob Hochstrasser Jr. opened the White Sulphur Springs House in 1880. By 1884, he had added a wing to accommodate well-to-do families who came for the summer. The spring was in the small white building at left. (Courtesy of Timothy J. Albright.)

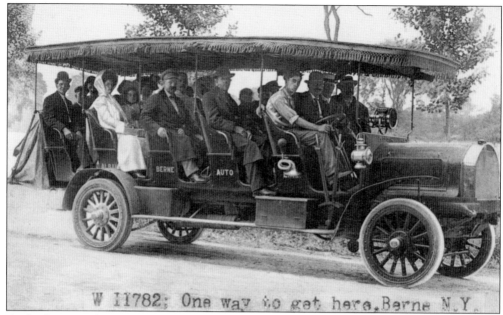

W 11782; One way to get here. Berne N.Y.

As the forests and soil became depleted, residents looked to other sources of income. Resourceful people capitalized on Berne's abundant waterways. Hotels, boardinghouses, and cottages dotted the area around Thompson's and Warner's Lakes. Horse carriages—and, later, auto buses—picked up vacationers at the Delaware & Hudson rail station in Altamont, drove them over the escarpment, and delivered them to their destinations. (Courtesy of Berne Historical Society.)

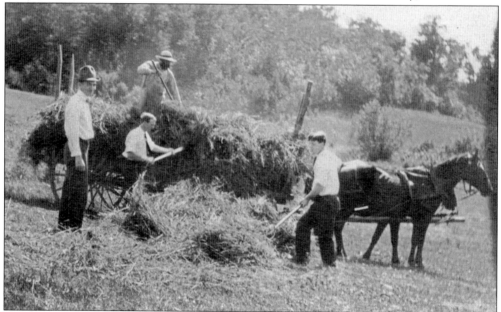

Summer boarders enjoyed the sunshine, country-style meals, and constant breezes in the hills of Berne. They swam, fished, and visited the cliffs and caves. Sometimes vacationers yearned to be part of everyday life and pitched in to help with haying and other chores; at the end of the day, they may have rethought that decision when dealing with sunburned faces, aching muscles, and blistered hands. (Courtesy of the Warner family.)

68

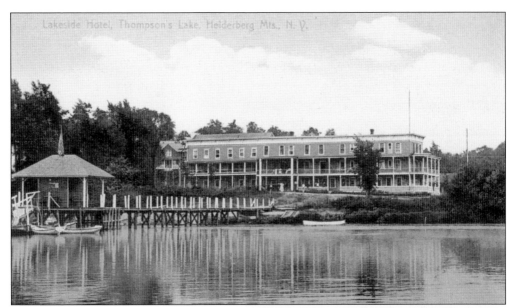

The Lakeside Hotel was a large inn on Thompson's Lake. Guests enjoyed dining, boating, swimming, clock golf, tennis, croquet, and hayrides. They danced, played billiards, and bowled at the waterfront casino. Many of the fruits, vegetables, and dairy products served in the dining room came from the hotel's 150-acre farm. The Lakeside Hotel is no longer standing. (Courtesy of Berne Historical Society.)

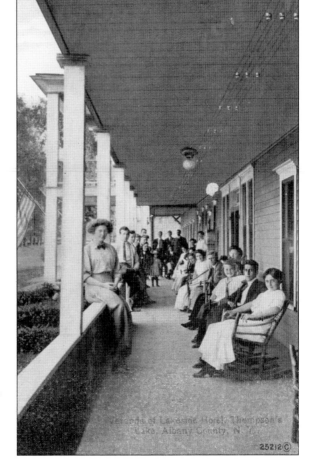

The long verandas at the Lakeside Hotel were restful places to sit, rock, talk, and flirt. Lake breezes fanned this group of boarders in 1912, providing respite from the heat of summer. The guests also explored the area—going for walks, climbing the Indian Ladder trail, and visiting the caves in Knox and Berne. (Courtesy of Barry and Terry Schinnerer.)

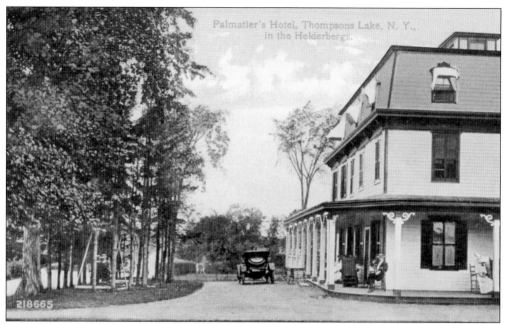

Palmatier's Hotel was across the road from the Lakeside Hotel. It was known for its dances and social club meetings. Guests relaxed in the summerhouse, shaded from the sun and cooled by gentle lake winds. They had an easy walk to the dock and the beach. During renovations in 1929, Palmatier's burned to the ground; it was never rebuilt. (Courtesy of Barry and Terry Schinnerer.)

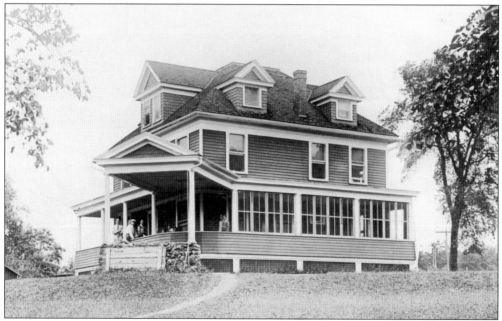

Warner's Lake in East Berne was a popular place for swimming, boating, canoeing, and fishing in the summer, and ice fishing and skating were common in the winter. Before refrigerators, people harvested ice to keep food cold during the warm months. Vacationers came up to Lake View Cottage (pictured) for a week or the whole summer. This building now houses a German restaurant called The Hofbrau. (Courtesy of Timothy J. Albright.)

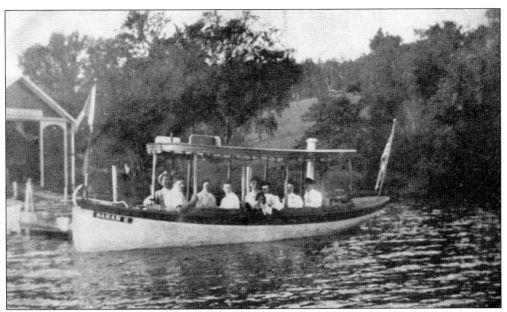

Warner's Lake had the added attraction of a steam launch, the *Sarah E*. The boat was shipped by rail from New York City to Altamont, and Arthur Warner hauled it to the lake using his horse and wagon. Before telephones were installed in East Berne, passengers raised a flag when they needed a ride. A trip across the lake cost 10¢. (Courtesy of Village of Altamont Archives and Museum.)

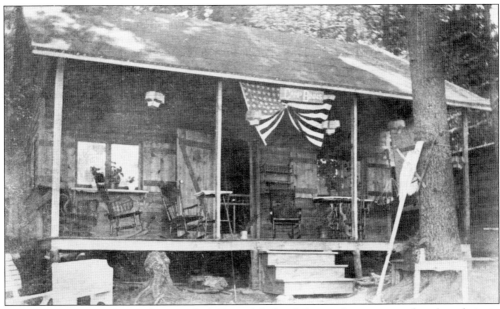

Binn's Grove was at the southern end of Warner's Lake. It featured a swimming beach and picnic grove, with a boat launch at Binn's Landing. The rustic cabins were popular with families and fishermen, who rented by the week, month, or season. In 1927, a furnished cottage cost $125 for the season. The land is now a private residence. (Courtesy of Berne Historical Society.)

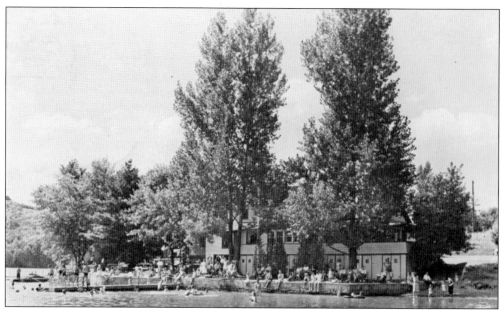

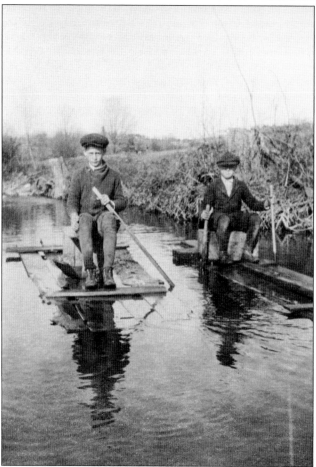

In the early 1900s, Jay Engle attracted customers to the Fur Trading Post with a trained bear. Harold and Agnes Pangburn opened Pangburns Store and Beach here in the 1940s and ran a bathing beach and snack bar. Swimmers enjoyed the water, and anglers cast lines from the stone wall. This building is now the home of Willard Osterhout, an author of books about Berne and Warner's Lake, who purchased the property in 1970. (Courtesy of Timothy J. Albright.)

Chester (left) and Hubert Miller showed that they could entertain themselves with a couple of rafts and poles. Despite their childhood antics, Chester grew up to raise registered Holsteins, organize a fiddle band, and serve as Berne's town clerk. Hubert raised Holsteins at Cole Hill Farm and was a charter member of Foxenkill Grange and Berne Volunteer Fire Company. (Courtesy of Frances Miller.)

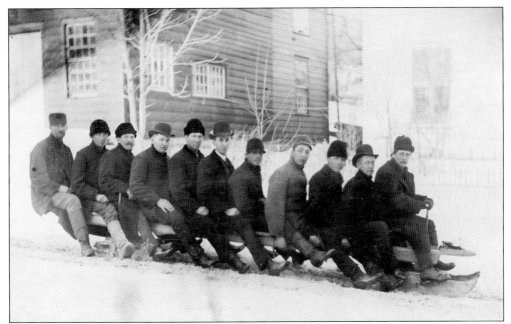

The long winters and steep hills of Berne made a winning combination for snow sports, including bobsledding. Eleven men, outfitted in wool coats and leather boots, braved the cold for a ride on this wooden sleigh. The man at the helm steered the front runners, while whoever was at the back of the sled was responsible for the push-off. (Courtesy of Berne Historical Society).

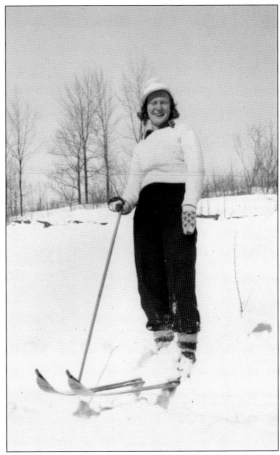

Skiing was another popular winter sport, as Ruth Anderson demonstrates on her wooden skis. From the late 1940s through the mid-1960s, people hit the slopes at Skiland on the north face of Cole Hill. It featured two 1,000-foot-long trails and two beginner trails, with rope tows and an overhead cable powered by a truck engine. The Foxenkill Grange sold refreshments at the snack bar. (Courtesy of Doris Palmer.)

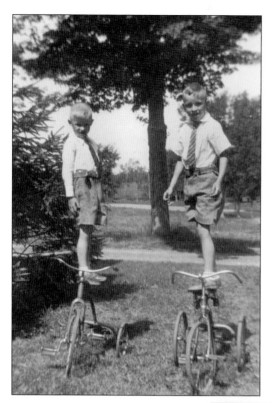

In 1938, Chester Warner moved his family back to the farm on Warner's Lake. He kept his sons Robert (left) and Carl busy cleaning stalls, milking cows, cutting firewood, haying with draft horses, selling vegetables to summer folks, and cleaning and sorting eggs. In their youth, the boys trained for farm life by performing feats of derring-do on their tricycles. (Courtesy of Wilma Kelly Warner.)

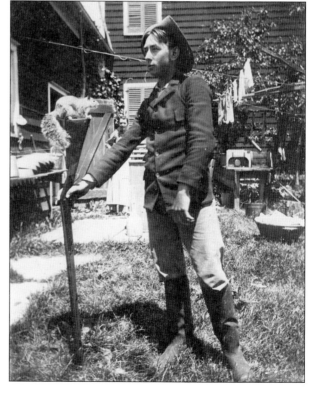

Philip Messer was a photographer who worked in Berne and the other Hilltowns. Many of his photographs were reproduced on postcards stamped with "P.J. Messer." Here, Vernon Wolford appears to be having a conversation with the squirrel on the stock of his rifle. (Courtesy of Berne Historical Society; photograph by P.J. Messer.)

Four

THE TOWN OF WESTERLO

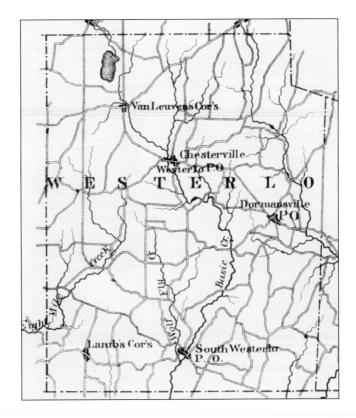

The town of Westerlo was created in 1815 from sections of Rensselaerville on the west and Coeymans to the east. The town took its name from Rev. Eilardus Westerlo, a Dutch Reformed pastor in Albany. The highest point is 1,142 feet above sea level. In 1830, the population of Westerlo was 3,321; in 1930, it was 1,220; in 2010, it was 3,361. (Courtesy of Berne Historical Society.)

Westerlo's upland is rugged, but it evens out to a hill-and-dale landscape toward the south. Revolutionary War veterans traversed the Hannacroix and Basic Creek valleys to reach the new lands. Settlers established villages in Chesterville, Dormansville, Lamb's Corners, South Westerlo, and Van Leuven's Corners. Working the land became a way of life for many inhabitants of Westerlo. (Courtesy of Catherine Snyder Latham and the Messer/Snyder family.)

The Green House is an outstanding landmark in the hamlet of Westerlo, formerly known as Chesterville. Archibald Green, a merchant, built this elaborate home in 1872. Also known as the Whitford House, it was subsequently owned by Harold and Helen Bell, who ran the general store next door. (Courtesy of Westerlo Historical Society and Westerlo Town Museum.)

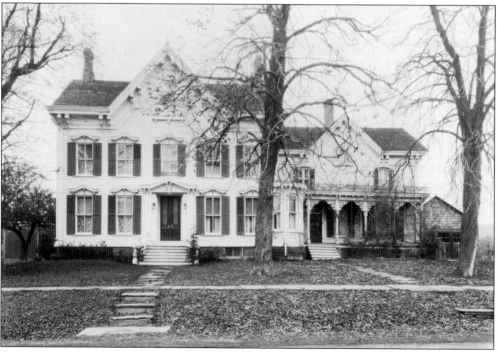

Helen Taylor and Harold Bell are pictured at right during their courting days. Hilltowners practiced a custom called "horning" (known in some other regions as a "shivaree")—a group of merrymakers quietly gathered beneath the newlyweds' bedroom window and struck up a cacophony using pots, pans, hammers, and horns. The couple would then invite the surprise guests in for an impromptu party. (Courtesy of Westerlo Historical Society and Westerlo Town Museum.)

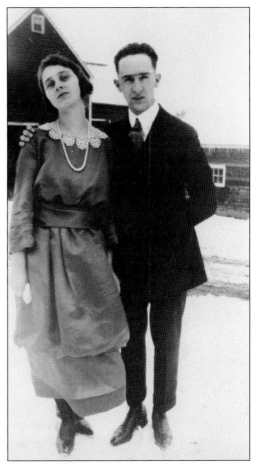

This store was once run by ? Grant and ? Eadie, potash producers in Chesterville. In the late 19th and early 20th centuries, the building was owned by Moses Smith, Jeremiah Green, and Archibald Green; it was later used as a garage by lessee Edwin Hannay. Vernon Whitford purchased the building in 1915 and opened a general store, which employee Helen Bell inherited upon Whitford's death in 1948. In 1983, the year after Helen's death, her husband, Harold, donated the historic Whitford Store—in honor of her memory—to the town of Westerlo for use as a library and museum. The Town of Westerlo Public Library opened on June 8, 1986. (Courtesy of Westerlo Historical Society and Westerlo Town Museum.)

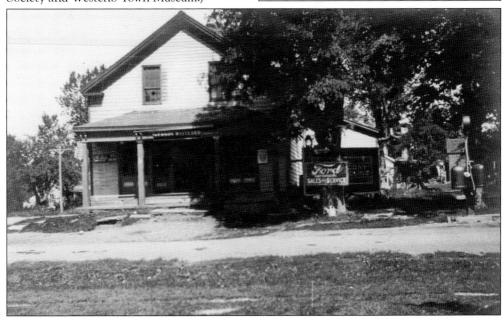

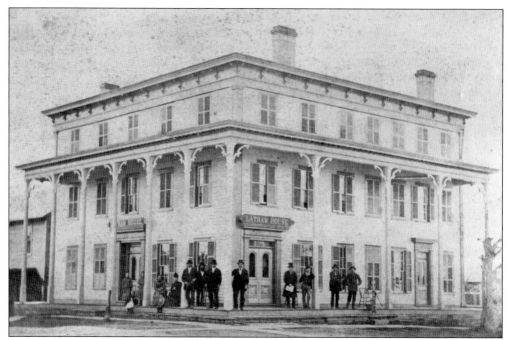

Henry C. Latham bought the Chesterville Hotel in 1876 and operated it as the Latham House (sometimes called Latham Hotel) until 1884; Latham is in the center of this photograph, at the front corner of the building. The three-story hotel offered rest and refreshment for townspeople, as well as for visitors passing through town. The building was destroyed by fire in the 1890s, and a bank is now located on the site. (Courtesy of Westerlo Historical Society and Westerlo Town Museum.)

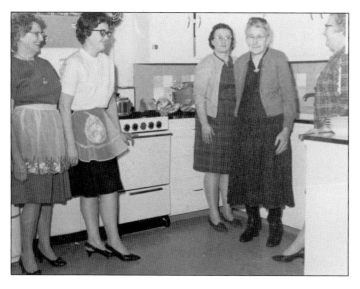

Basic Creek runs through South Westerlo. The town was originally called Smith's Mills after the prominent family who built mills, ran the first general store, and operated a potash business there. The Congregational Christian Church was built in 1873, and the Ladies Aid, pictured around 1960, has a long history of supporting the church's mission. (Courtesy of Westerlo Historical Society and Westerlo Town Museum.)

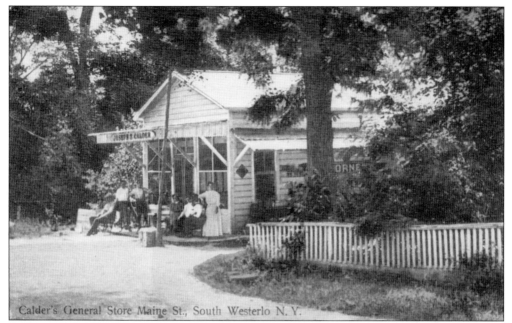

Calder's General Store Maine St., South Westerlo N. Y.

William H. Calder once operated a woolen mill in South Westerlo. His descendant Joseph Calder had no desire to join the family business and instead became the proprietor of Calder's General Store. In the 1920s, he achieved local notoriety for running a dance hall and speakeasy. (Courtesy of Westerlo Historical Society and Westerlo Town Museum.)

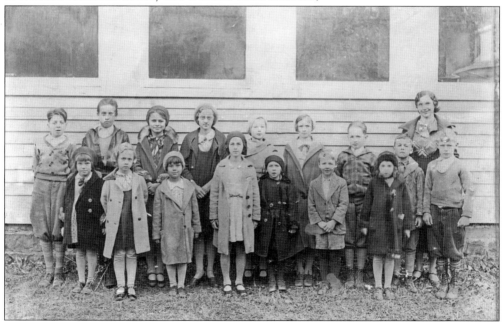

Children attended one-room schoolhouses throughout the town. The students of School District No. 1 in South Westerlo donned their coats to be photographed with teacher Margaret Boomhower Bogardus. The Greenville and Berne-Knox districts became centralized in the 1930s. As the small schoolhouses were phased out, students rode buses to one of the central districts. (Courtesy of Westerlo Historical Society and Westerlo Town Museum.)

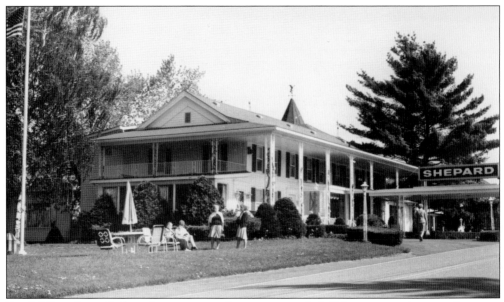

South Westerlo swelled to a boomtown in the summer, with 1,000 visitors in the area. Augustus and Gladys Shepard created a very popular summer resort at Shepard Farm. It was a haven of rest and recreation for vacationers from New York City and entertained as many as 200 guests at a time. (Courtesy of Westerlo Historical Society and Westerlo Town Museum.)

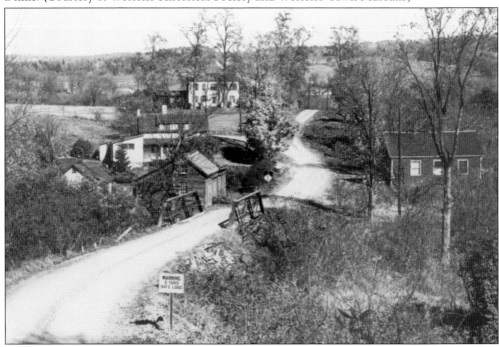

Waterpower from the Hannacroix Creek in Dormansville attracted early settlers John Gibbons and Jacob Dorman, for whom the hamlet was named. Heading north over the bridge on the Clarksville road, a traveler in the early 1900s saw School District No. 12 on the right, a shoe shop on the left, and, farther up the road, the large white Onderdonk farmhouse. (Courtesy of Westerlo Historical Society and Westerlo Town Museum.)

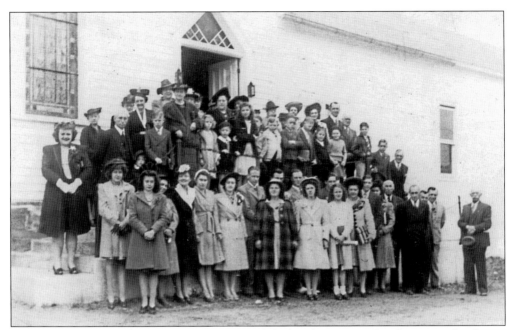

Mills appeared along the Hannacroix Creek, and the hamlet prospered in farming and industry. Loads of hay, grain, and quarry stone were transported down the plank road to the Hudson River landing in Coeymans. The Dormansville United Methodist Church, founded in the 1840s, remains a center of community activity. In 1941, the congregants gathered outside in their Easter finery. (Courtesy of Doris Palmer.)

In 1915, Channing Swart was postmaster at the Dormansville Post Office, and Albert Applebee was the rural mail carrier. Swart's daughter and wife, Frances and Ethel, are shown sitting outside the building. The post office was an official station for fingerprinting foreign laborers who worked on Route 143. The old mailboxes are maintained in the town's museum. (Courtesy of Doris Palmer.)

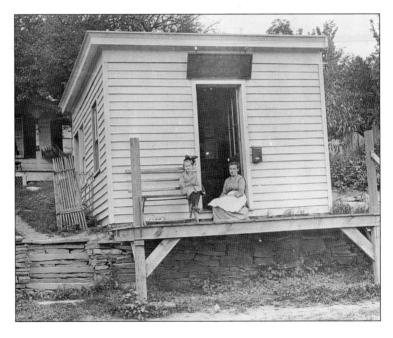

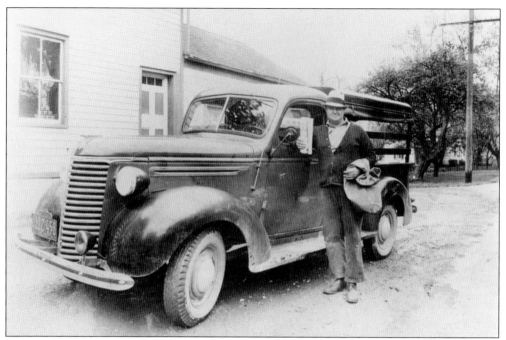

Walt Fisher heads out on his mail route. Originally, rural residents had to pick up their mail at the post office or pay a private carrier for delivery. The national Grange organization lobbied for free rural mail service, which became official in 1896. In 1913, the new parcel post service created a boom in sales of mail-order merchandise to customers in rural areas. (Courtesy of Robert and Harriet Peck.)

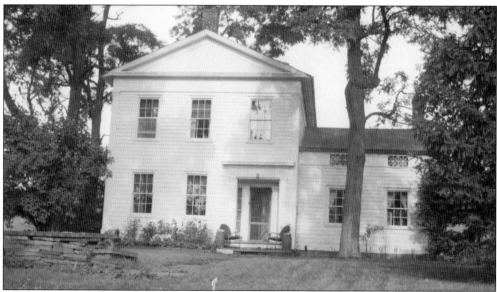

In 1848, Peter Onderdonk (Underdonk) built this Greek Revival farmhouse in the Tan Hollow section of Dormansville. The Gibbons family, and then the Palmer family, owned the farm. Passengers used the bluestone step out front for getting into and out of carriages. Although the step was slated for removal when the road was improved, the Palmers fought to preserve the historic stone, which stands today. (Courtesy of Doris Palmer.)

In the 1940s and 1950s, Arthur Palmer ran the old Onderdonk place as a small dairy farm. During the blizzard of 1958, he crawled through an upstairs window to get to the second floor of the barn. After milking the cows, he had no way of getting the milk to market and was forced to dump it in the snow. (Courtesy of Doris Palmer.)

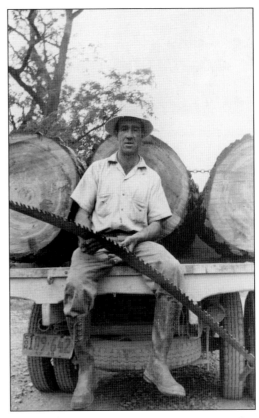

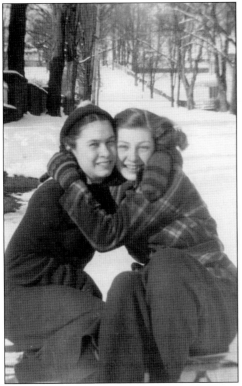

Doris Boughton (left) grew up in Rensselaerville. In 1940, she married Arthur Palmer, settling on his family's farm in Dormansville. There, she raised a family, worked side-by-side with her husband, served 60 years on Westerlo's election board, and, later, worked in the food services department at Greenville Central School District. (Courtesy of Doris Palmer.)

Laura Palmer, shown here with her cat Andy, grew up on the Gibbons-Palmer Farm. Besides the usual farm chores, she played with her friends and her brother, Leland. They attended school in Greenville. Palmer, an animal lover from an early age, is still involved in caring for cats. (Courtesy of Doris Palmer.)

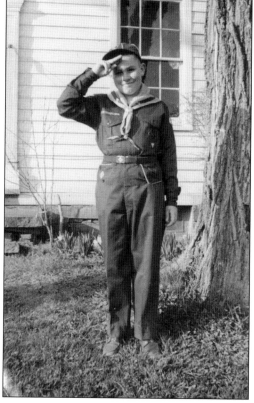

Cub Scout Leland Palmer proudly saluted in front of the family farmhouse in Dormansville. His mother, Doris, was an inveterate photographer. She used a Kodak Six-16 camera, which produced higher quality photographs than a simple box camera. (Courtesy of Doris Palmer.)

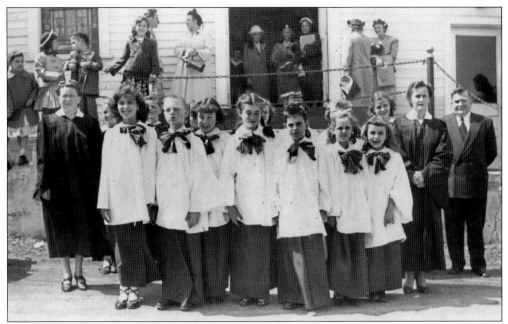

Laura Palmer (center front) sang with the Dormansville United Methodist Church junior choir. Frances Swart (at left, wearing a dark choir robe), a respected schoolteacher, was the organist, and Kathleen Trenchard (at right, wearing a dark choir robe) served as choir director. The choir, in their white surplices and red skirts, sang traditional hymns like "The Church's One Foundation" and "I Need Thee Every Hour." (Courtesy of Doris Palmer.)

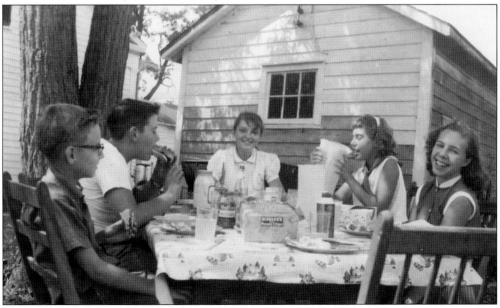

In August 1959, Doris Palmer's Sunday school class partied under the farmstead trees. From left to right, Roland Tozer, Leland Palmer, Alice Tallman, Alliene Applebee (drinking out of a pitcher), and Janet Loucks amused themselves around the table. Doris was a tireless member of the United Methodist Church, serving as an officer, arranging altar flowers, and working at church suppers. (Courtesy of Doris Palmer.)

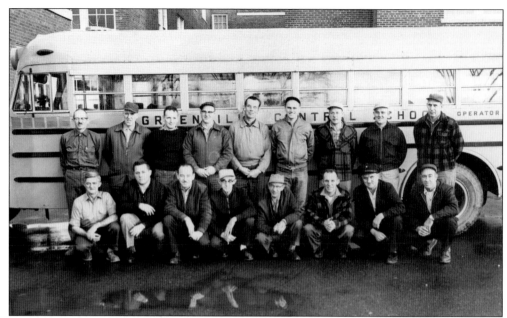

Around 1960, changes in state regulations required, among other things, that milk be kept in bulk storage tanks instead of 10-gallon cans. Sadly, the new regulations put many small dairy farmers out of business. Arthur Palmer, at far right in the first row, found employment as a custodian and bus driver for Greenville Central School District. He continued to farm, raising beef cattle and first-calf heifers. (Courtesy of Doris Palmer.)

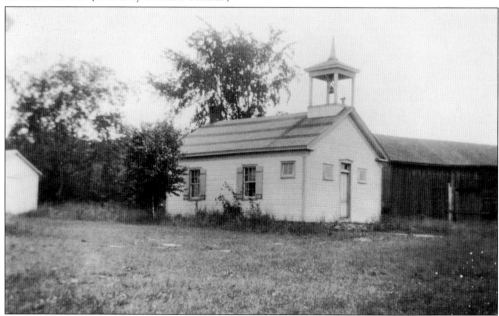

The land in the southwestern section of Westerlo has broad fields well suited for agriculture. Over 200 years ago, the Lamb, St. John, and Ingalls families settled in the area now known as Lamb's Corners. For a time, the farms prospered. A Methodist church served the community, along with a few shops, a blacksmith, and this small one-room schoolhouse. (Courtesy of Westerlo Historical Society and Westerlo Town Museum.)

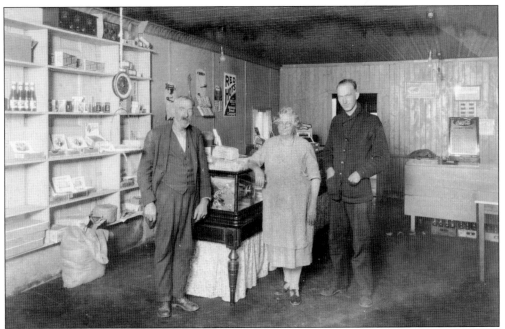

Snyders Corners, a crossroads in the northwest section of Westerlo, was once home to a sawmill, cider mill, garage, store, farm, and tavern. George and Viola Snyder built their home and business there in 1903. They are pictured with their son Harold in their small store and ice cream parlor in the 1930s. (Courtesy of Catherine Snyder Latham and the Messer/Snyder family.)

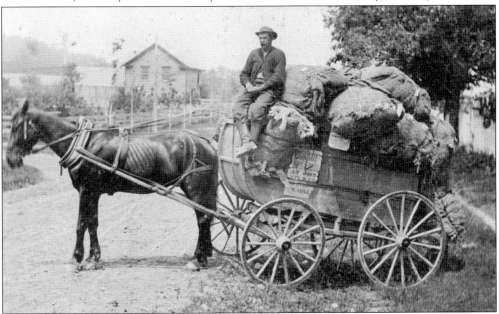

Peddlers were a welcome sight for those who lived far from the hamlets. The traveling salesmen brought clothes, dry goods, pots and pans, tinware, spices, and almost anything that could fit in a wagon. Some peddlers made sure to stop at the home of a good cook at suppertime. This unidentified ragpicker, with a horse named Napoleon, collected bundles of rags for resale to paper mills. (Courtesy of Dennis and Sue Fancher.)

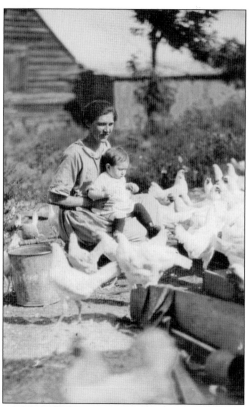

Christina Messer was born in the wilderness area of western Berne and helped with the hops harvest as a child. She married Walter Snyder and moved to the Snyder Farm in Westerlo, where they raised a large family. She lived to see many grandchildren and great-grandchildren grow up. Here, she sits among the hens with her oldest son, John. (Courtesy of Catherine Snyder Latham and the Messer/Snyder family.)

Rev. Reuben Stanton came to Westerlo from Connecticut in 1787. A minister, farmer, and surveyor, he mapped out several properties and received farmland in payment. In this 1890 image, the Stanton horses draw a large load of hay into the farmyard. The 21st-century Stanton Farms offer hayrides, corn mazes, apple and pumpkin picking, and share an old-fashioned honor system payment box. (Courtesy of Dennis and Sue Fancher.)

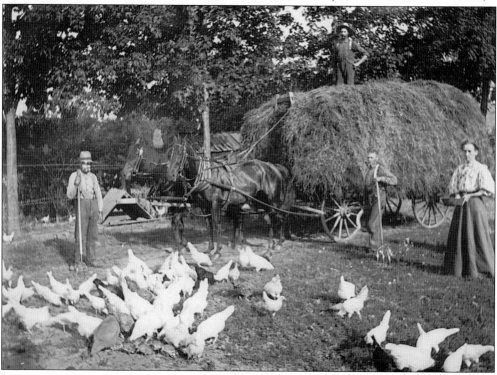

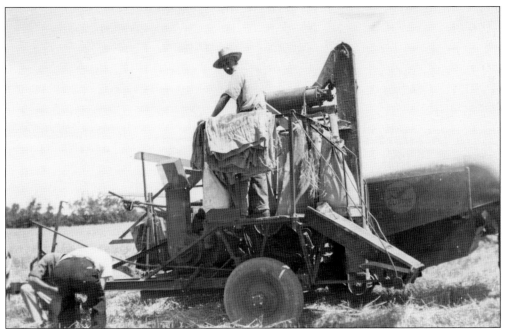

Harold Boomhower Sr. grew up on the farm on Boomhower Farm Road. He cut the trees to build his own home on Cedar Grove Lane and raised his family there. Here, he is threshing, probably with his brother Robert and father, Charles Boomhower. The burlap bags were ready to be filled right there in the field. (Courtesy of the Boomhower family.)

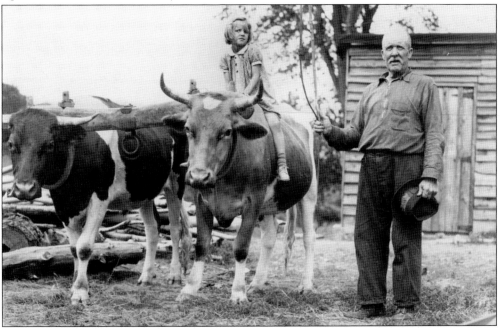

Marjorie Lounsbury was one of 17 children of Theodore and Lena Fisher Lounsbury. In 1938, she spent time on the family farm in Dormansville with three of her siblings and their grandfather John Fisher, whose two-year-old oxen were gentle enough for Marjorie, Harold, Harriet, and Theo to ride. (Courtesy of Robert and Harriet Peck.)

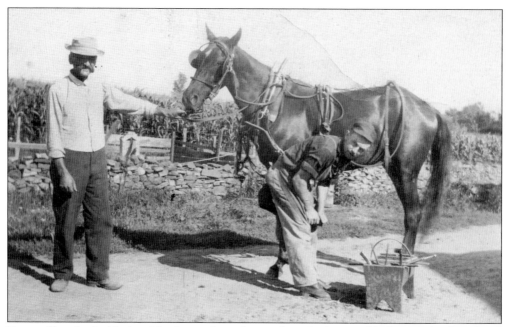

Every village had a blacksmith who performed several vital roles: as a blacksmith, he forged and repaired tools and other items made of iron; as a wheelwright, he kept busy making and repairing the iron bands on wagon wheels; as a farrier, he cared for the hooves of horses and created their horseshoes. (Courtesy of Dennis and Sue Fancher.)

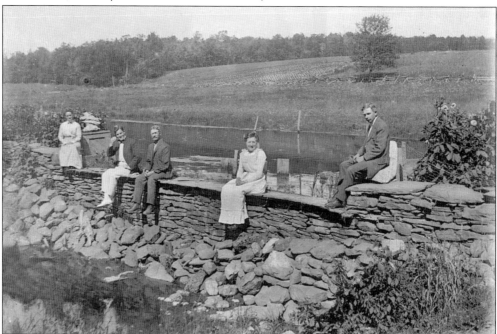

This milldam in South Westerlo was a pleasant place to sit on a summer afternoon. Water from the millpond went down a raceway to turn the mill's waterwheel. Waterpower was not always reliable, being subject to spring floods, summer droughts, and winter freezes. In the days before refrigerators, ice was harvested from the pond for year-round use. (Courtesy of Dennis and Sue Fancher.)

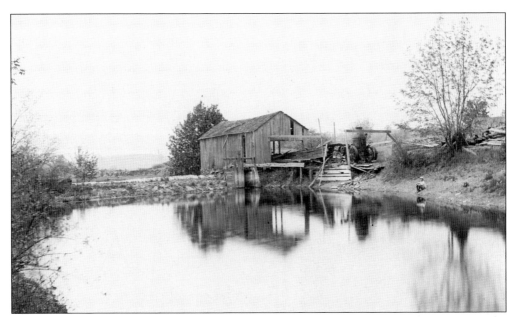

Lumber was the main building material in the Hilltowns, and the sawmill was essential to the growth of the communities. Waterpower gave way to the more reliable steam engine, which is visible to the right of the building. In this c. 1910 image, Jesse Britton, son of sawmill owner Nathan Britton, is fishing on the bank of the old Snyder sawmill pond. (Courtesy of Westerlo Historical Society and Westerlo Town Museum.)

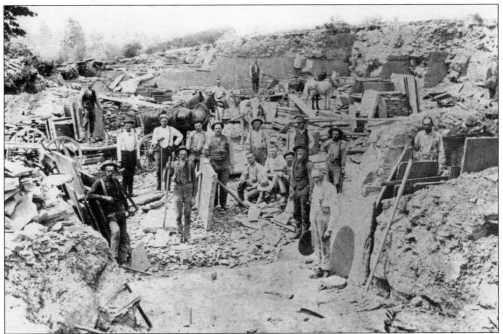

At one time, Westerlo contained several working quarries. Stewart's quarry was on Stewart Road in the far northwest corner of town. The stone was used in chimneys, foundations, fireplaces, stone walls, retaining walls, and dams. Today, a walk past old buildings will reveal many bluestone foundations. (Courtesy of Rensselaerville Historical Society.)

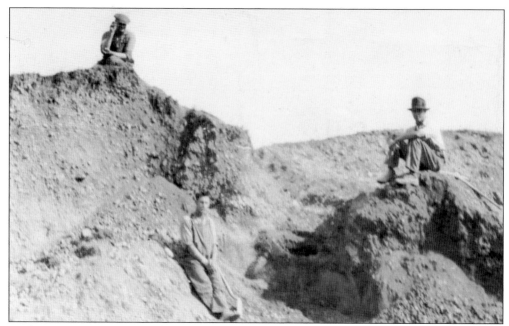

By the 20th century, concrete had largely supplanted Helderberg bluestone as a building material. Local farmers seized the opportunity to supply the construction trade with sand and gravel, important ingredients in the manufacturing of concrete. The Walter Snyder Farm had a sand and gravel pit, shown here with three unidentified workers taking a break from their labors. (Courtesy of Catherine Snyder Latham and the Messer/Snyder family.)

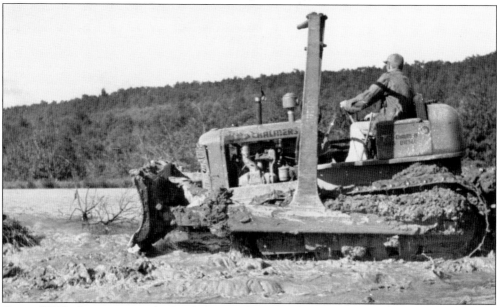

George W. Snyder grew up on the family farm in Westerlo. He served in the US Army during World War II, landing on Utah Beach during the D-Day invasion. After being honorably discharged, he returned to Westerlo, started a small excavating business, married Mary Brennan, and raised a family. Here, he prepares the ground for a pond at Camp Pinnacle in New Scotland. (Courtesy of Mary-Jane Snyder Araldi.)

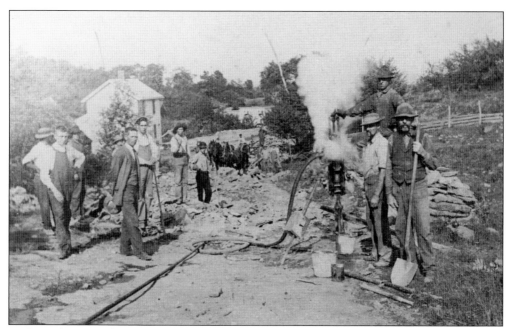

In the early 1900s, this crew blasted a roadway near Bear Swamp. The swamp, formed during the retreat of the last glacier, spawned legends about people getting lost in its depths. The area has a relic stand of rhododendrons—the northernmost in New York State. Bear Swamp has been designated as a National Natural Landmark and is owned by the Nature Conservancy. (Courtesy of Westerlo Historical Society and Westerlo Town Museum.)

Clifford Hannay, pictured with his wife, Hazel Barber Hannay, used his mechanical and electrical knowledge to invent a solution to the problem of delivering fuel oil via heavy cans. In 1933, he developed a hose reel (the Hannay reel) that allowed the delivery person to unwind the hose and take the nozzle to the customer's oil tank while leaving the hose attached to the truck. (Courtesy of Hannay Reels.)

The Hannays ran a small gas station and luncheonette in this building. Clifford Hannay's innovative reel led to the establishment of Clifford B. Hannay & Son, which originally produced 25 reels per month. The luncheonette became the manufacturing building, where Hannay preferred hands-on work to running the business. This building is now a museum for Hannay Reels. (Courtesy of Hannay Reels.)

The Hannay ingenuity led to other applications of the original reel design. The company produced hand-cranked and electric-powered reels, which improved the ease and safety of delivering liquids that ranged from chemicals used in manufacturing plants to water used with firefighting equipment. This photograph shows an employee on the shop floor in the early days of the business. Hannay Reels has been nationally recognized as a safe work environment. (Courtesy of Hannay Reels.)

This photograph shows a typical use for the Hannay reel. The family-run reel business has long had ties to the town of Westerlo, starting with Andrew Hannay, who organized a band of patriots during the Revolutionary War. As the town's largest employer, the company has contributed in many ways to the welfare of the town, and its investment in the community continues today. (Courtesy of Hannay Reels.)

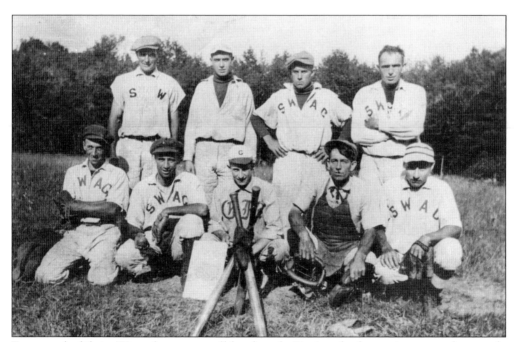

Fortunately, life in Westerlo was not all hard work. During the long winter months, people looked forward to sunshine, flower gardens, Bender melons, and baseball. The South Westerlo team appears ready to take on all challengers in this grassy baseball field—a reminder of the days before AstroTurf and designated hitters. (Courtesy of Westerlo Historical Society and Westerlo Town Museum.)

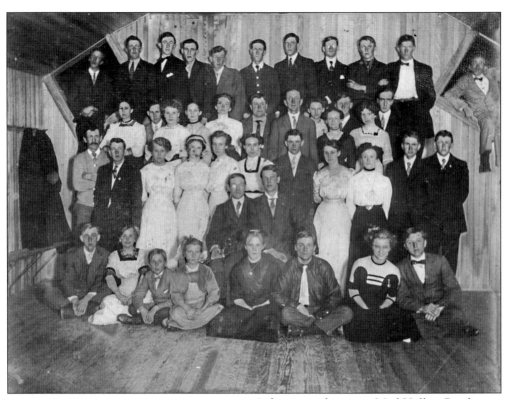

A dam turned swampy Mud Hollow Pond into the more appealing Lake Onderdonk. The lake attracted summer vacationers, prompting Eugene Sisson to build a dance hall. His Dewitt Casino, with a snack bar and bowling lanes, is locally known as the Red Baron. Here, members of the Onderdonk Dancing School take a break between sets. (Courtesy of Catherine Snyder Latham and the Messer/Snyder family.)

Mary Snyder held onto her hat as she glided across the ice in 1948. Skaters looked forward to clear, cold days when the ice was smooth and thick enough for a crowd. They skated at millponds and at Lake Onderdonk, warming up at bonfires built along the banks. (Courtesy of Mary-Jane Snyder Araldi.)

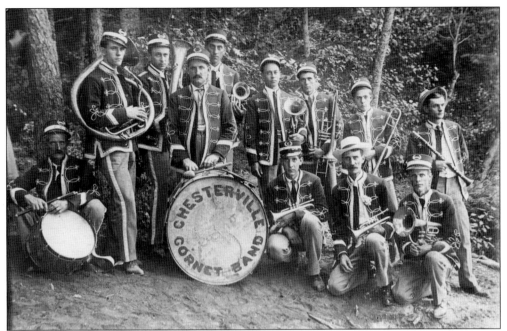

The Chesterville Cornet Band, shown around 1910, formed in 1884 and later purchased a bandwagon from the Richmondville town musicians. In Westerlo's 1940 Memorial Day parade, the two remaining members of the Chesterville Cornet Band, Edwin Hannay and John Peck, rode in the wagon, sitting in their old seats with their original uniforms and instruments. (Courtesy of Westerlo Historical Society and Westerlo Town Museum.)

The 1940 Memorial Day parade also featured a patriotic float with Miss Westerlo and her court. Dorothy Britton was crowned queen, and Jesse Tomkins played Uncle Sam. Parades—with fire engines, marching bands, rows of Scouts and ball teams, and floats festooned in crepe paper—have always drawn crowds in the Hilltowns. (Courtesy of Westerlo Historical Society and Westerlo Town Museum.)

Around 1950, a German man named Fencil Frank featured local entertainers in a special type of variety program called a minstrel show. The production toured locally, with stops at Hiawatha Grange, Ravena Grange, and Woodman's Hall. Here, Clarence Bates (left), Marjorie Lounsbury, and Gerald Woodruff entertain with a Western number. (Courtesy of Doris Palmer.)

This bowl-shaped area in South Westerlo was a natural gathering place for picnics, church outings, ball games, sledding, and swimming in the millpond. From 1949 to 1953, Clearview Speedway held stock-car races on its one-third-mile oval dirt track, as well as hosting horse shows, wrestling matches, and fireworks displays. It is now the Blaisdell-White Memorial Town Park. (Courtesy of Westerlo Historical Society and Westerlo Town Museum.)

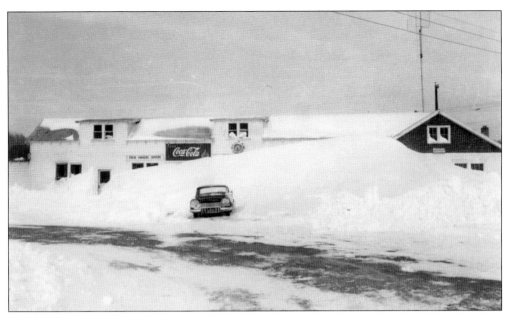

Around Valentine's Day in February 1958, a blizzard pounded the area for three days, complete with fierce winds and temperatures that reached 15 degrees below zero. Many feet of snow piled up, and plows broke down in the heavy snow. Workers reached stranded families on a snowcat loaned by Belleayre Ski Center and a hastily converted Oliver Cletrac tractor. Snow reached to the rooftops, as shown at Snyder's Corners. (Courtesy of Westerlo Historical Society and Westerlo Town Museum.)

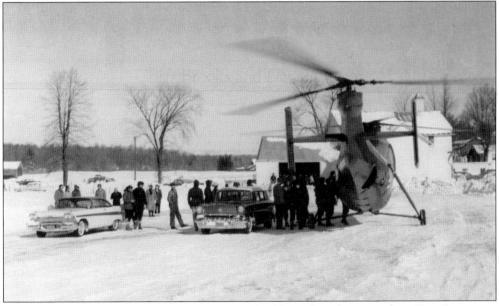

A state of civil emergency was declared after the blizzard. Helicopters from Fort Devens in Massachusetts dropped supplies and transported people. A fuel oil truck from Ravena was dispatched to stay as long as needed. The Red Cross brought cots and blankets for workers and food bundles for stranded families. After the airport's runway was cleared, the Hannay company plane made food and hay drops. (Courtesy of Westerlo Historical Society and Westerlo Town Museum.)

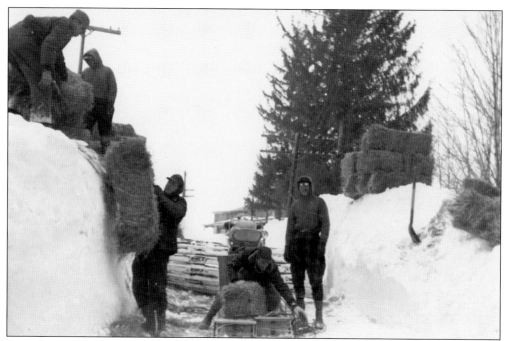

Some farmers could not transport hay to their animals. After hay bales were airdropped, men loaded them onto improvised toboggans for delivery to the livestock. The town ran out of bread, but none was available in Albany. Even with the outpouring of help, 18 families were still stranded several weeks after the blizzard. (Courtesy of Catherine Snyder Latham and the Messer/Snyder family.)

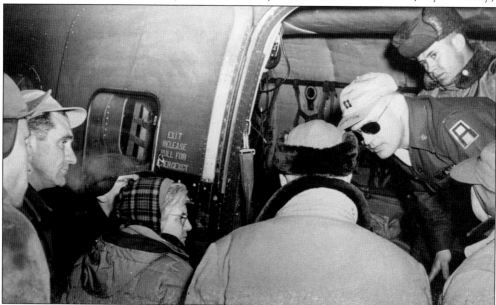

Dr. Anna Perkins (in plaid hat) boards a helicopter to reach a patient snowbound by the blizzard. She came to rural Westerlo in 1928, a time of outdoor plumbing, unplowed roads, and home births. She kept up with changes in medicine but continued to make house calls. The beloved country doctor treated six generations, traveling by foot, snowshoe, car, or helicopter to see patients. (Courtesy of Westerlo Historical Society and Westerlo Town Museum.)

Five

THE TOWN OF KNOX

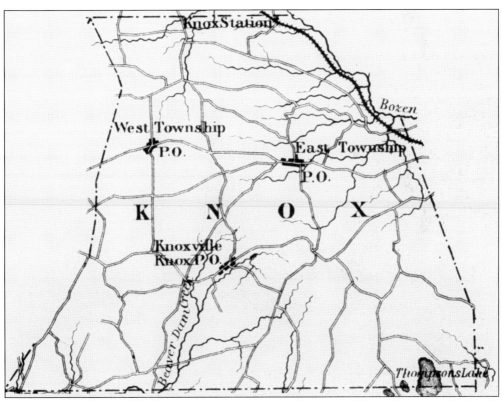

In 1822, the northern half of Berne was incorporated as the town of Knox, becoming the fourth and final Hilltown. The origins of its name are lost in obscurity. It was possibly named to honor John Knox, a Scottish clergyman, or Maj. Gen. Henry Knox, a Revolutionary War hero. In 1830, the population was 2,189; in 1930, it was 863; in 2010, it was 2,692. (Courtesy of Berne Historical Society.)

The early hamlets in Knox were East Township, Lee's Corners, Peoria (or West Berne), West Township, and Knoxville, which is now the town center. While it is a rural, agricultural area like the other Hilltowns, Knox is also nationally known for its ancient caves and fossils. Perhaps Pauline (left), Grace (center), and William Salisbury are looking forward to a bright future as they ponder the town's rich history. (Courtesy of Pauline E. Williman.)

Platycerus dumosum. Zaphrentis. Pentamerus Galeatus. Tentaculites.

SPECIMENS OF HELDERBERG FOSSILS.

The exposed cliff face of the Helderberg Escarpment reveals layers of rock that document 500 million years of geological history and contain a rich array of fossils. According to the *Helderberg Escarpment Planning Guide*, the area has been called "the birthplace of American paleontology" (the study of fossils). As water flows through the limestone layer, it dissolves and erodes the rock. This creates karst terrain and produces caves, sinking streams, sinkholes, complex underground drainage systems, and thin soil. (Courtesy of John Elberfeld.)

The northeast section of Knox sits on the edge of the Helderberg Escarpment. The flat rock in the photograph is naturally occurring "limestone pavement." While the escarpment area is important for geologic study and recreation, the terrain presents challenges for the people who live there. The first settlers, accustomed to richer farmland in the lowlands, struggled to wrest a living from the unforgiving soil. (Courtesy of Timothy J. Albright.)

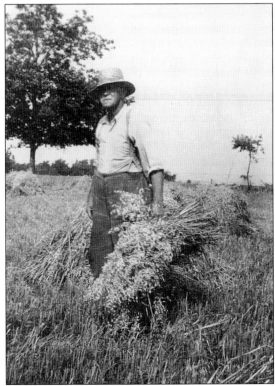

Much of the soil in Knox is a thin layer of rock and soil particles over limestone. Poor drainage makes the soil prone to erosion or quick to become saturated with water. Despite these difficulties, farmers have continued to work the land. In this image from the 1940s, Henry Alonzo Whipple, a descendant of early settler and businessman Malachi Whipple, "sets" his oat crop, putting it in stacks for threshing. (Courtesy of Deb Whipple Degan.)

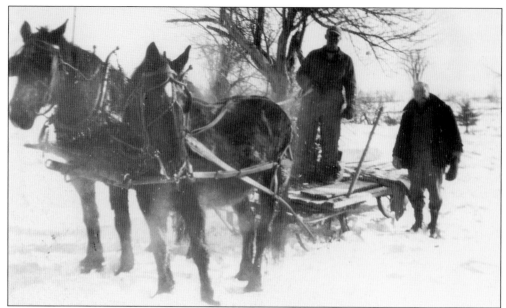

In the "Stories" section of the Albany Hilltowns website, Homer Warner remembered the 1940s as follows: "In the winter, if the roads were drifted shut and driving a vehicle was out of the question, my father would often hitch up the team to the bobsleigh." Here, the Whipple team is reminiscent of the steaming horses in Alfred Stieglitz's famous photograph, "The Terminal." (Courtesy of Henry A. Whipple.)

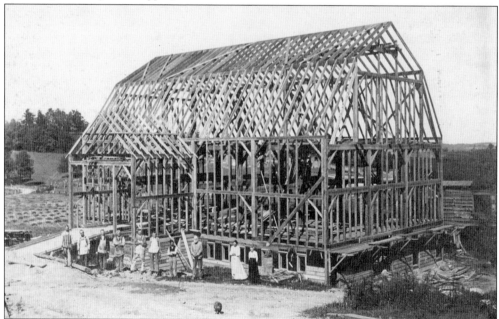

The barn was one of a farmer's biggest investments. During the 1800s, farming shifted from the production of grain to dairy, and the old Dutch grain barns gave way to larger, rectangular barns built for housing cattle, equipment, and hay. After the floor and stone bridge were put down, as many as 100 neighbors would come to help raise the barn or prepare a huge feast for the workers. (Courtesy of the E.J. Hogan Collection.)

Farm children, including Robert and Ann Whipple, helped with the chores. In the "Stories" section of the Albany Hilltowns website, Homer Warner recalled that, "as a boy, one of my first morning chores was to climb the hillside pasture . . . to find and bring in the two draft horses, Molly and Jerry. This was not an easy job because they didn't come willingly, but I always got it done." (Courtesy of Henry A. Whipple.)

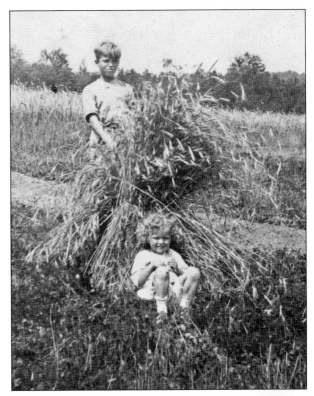

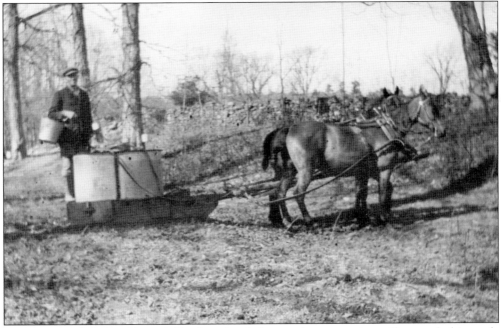

One day in early spring, Harry Gibbs drove his sledge over bare ground to collect sap for his maple syrup operation. The son of Eve Ann Ball and Albert Gibbs, Harry was born on a farm in Berne. As an adult, he owned Hillendale Farm on Pleasant Valley Road in Knox, and his home was the site of many Ball-Gibbs family reunions. (Courtesy of Frances Miller.)

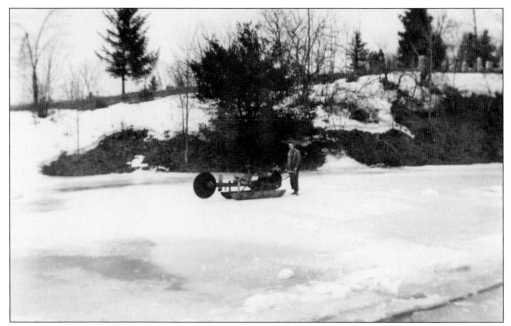

In the days before electric refrigeration, ice was a very important commodity for keeping food fresh. When the ice was about a foot thick in ponds, ice harvesting could begin. Men scraped off the snow and scored the surface in a huge grid to create blocks of uniform size before cutting through the ice with hand or mechanical saws. (Courtesy of Elizabeth Stevens.)

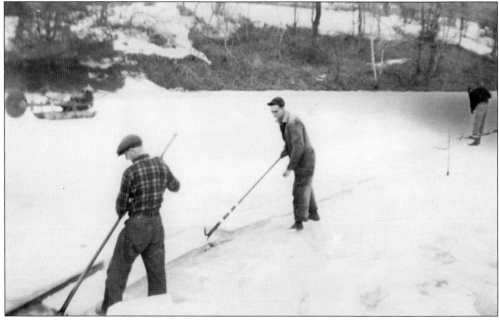

Harvesting ice was a cold, wet, and risky business, because one false step could send a person into freezing water. Here, workers have created a channel to float the ice blocks, which could weigh up to 200 pounds, to the shore or onto a sledge. The huge blocks were packed in icehouses, insulated with layers of sawdust or wood shavings, and used throughout the year. (Courtesy of Elizabeth Stevens.)

106

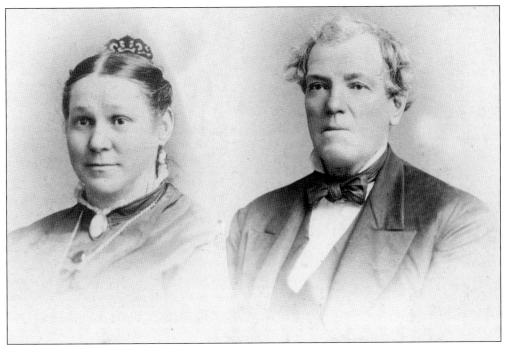

Johan Jacob Sholtes (Shultes) served in the Revolutionary War and later leased 160 acres on Rock Road from the Van Rensselaer patroon. He willed the farm to his grandson Jacob Sholtes, pictured above with his third wife, Angelica. In 1852, Jacob built the large farmhouse that still stands today. Over the years, the family name has been spelled Sholtes, Shoultes, Shultes, Scholdus, Scholtes, and Schouldes. (Courtesy of Berne Historical Society.)

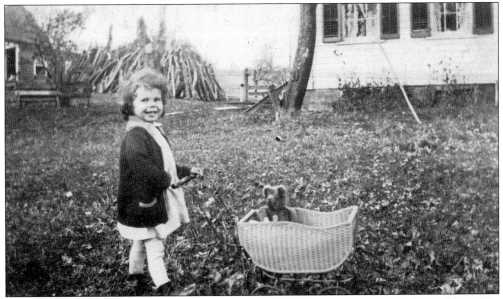

A smiling Virginia Sholtes takes her teddy bear out for a ride, probably at the Rock Road farm. Her father, Friend, was a grandson of Jacob and Angelica Sholtes. Friend had been a trolley conductor in Schenectady and later bought the farm property from his brother. The Sholtes family retained the farm for 175 years, finally selling it in 1958. (Courtesy of Allan Deitz.)

Around 1800, William Shultes built this farmhouse in West Berne on the Foxenkill. He grew grain, threshing and storing it in his Dutch barn. Later, the Haverly family ran a dairy operation here. While this structure is known as the oldest house in the hamlet of West Berne, it is actually located just over the town line in Knox. Today, the well-maintained buildings include a hops house. (Courtesy of Kenneth and Pamela Malcolm.)

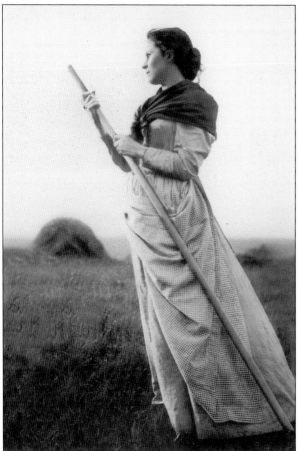

In 1899, Susan Roach Whipple posed in vintage clothing for a pictorial essay, "The Farmer's Wife," by award-winning photographer Emma Farnsworth. The farmer's wife in the Hilltowns faced many challenges. She contended with harsh weather, an unreliable water supply, isolation, the daily demands of raising a family, keeping a well-stocked pantry, and a multitude of chores. (Courtesy of Henry A. Whipple.)

> *Washington Pie Three apples*
> *grated, the juice & grated*
> *kind of one lemon. one teacup*
> *sugar, one egg whip together*
> *let it scald over boiling water*
> *sufficient to become jelly*
> *When cold put between layers*
> *of cake as plain or as rich*
> *as you please.*

This recipe for Washington pie, a cake with apple jelly filling, is from the cookbook of Ellen Saddlemire, which was assembled around 1888. Saddlemire glued her handwritten recipes and sundry newspaper articles onto the pages of an old book from the Albany County Board of Supervisors. Her notes for "cheat" oysters made from codfish say, "the oysters may be a cheat, but the recipe is genuine." (Courtesy of Knox Historical Society.)

Alta (left) and Harrison Salisbury do some "horsing around" in the barnyard on Ketcham Road. Farmers' wives, in addition to raising a family and working on the farm, sought other sources of income to help make ends meet. Alta Salisbury was also a schoolteacher and bus driver. Many women welcomed cottage industries, like pillbox production, which allowed them to earn money while working at home. (Courtesy of Pauline E. Williman.)

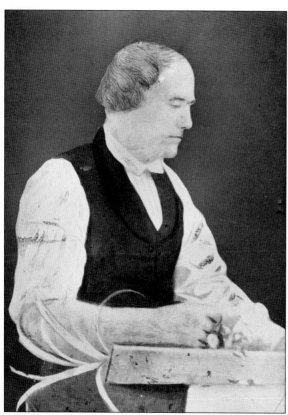

In 1806, Nathan Crary founded the industry that turned Knox into the "Pillbox Capital of the World." A fortuitous combination of abundant raw materials, eager labor supply, and a ready market drove this local industry for nearly a century. The pillboxes were small, two-piece basswood boxes that were assembled by Knox residents and sold by the millions to patent medicine companies in New York City. (Courtesy of Knox Historical Society.)

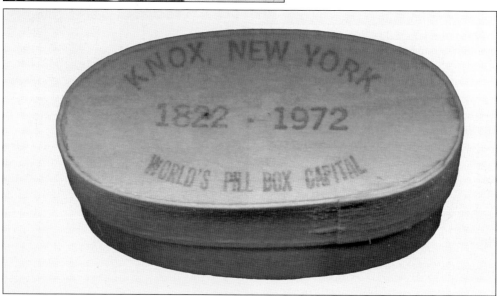

In 1830, Crary and his brother Edward registered a patent for manufacturing basswood pillboxes. Workers produced these by the thousands in their homes and/or in small factories. The round or oval boxes were made of very thin strips of wood. In spite of the millions of boxes manufactured, because of their fragile structure and disposable nature, very few remain. (Courtesy of Knox Historical Society.)

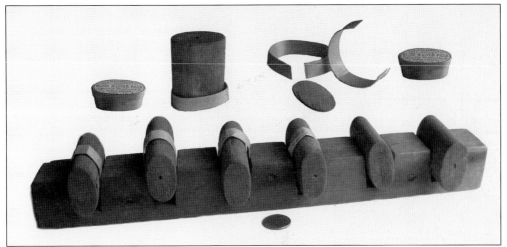

Workers shaved thin strips of basswood, earning $1.50 for 48,000 shavings in a typical day. The strips were bent, overlapped, and glued around oval or round forms. A man could earn $1 a day stamping out 24,000 tops and bottoms. Skilled women and children working at home could turn out 1,600 pillboxes a day, earning approximately 12¢ per 400. (Courtesy of Knox Historical Society.)

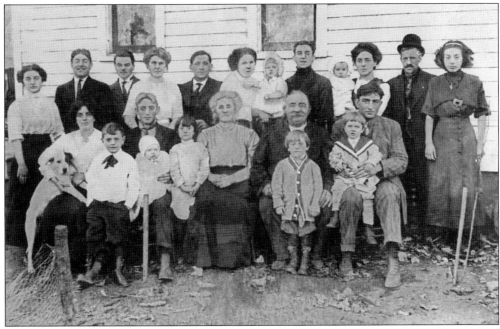

Pillboxes were packed in "tierces" of 10,000 and then carted over the escarpment to the Hudson River for shipment to New York City. Sherman's Cathartic Lozenges, Dr. Newton's Jaundice Bitters, and Latcher's Anti-Dyspeptic Blood and Liver Pills were all packed and sold in little basswood pillboxes from Knox. The Quays, shown here at a family reunion in 1914, were prominent in the pillbox industry. (Courtesy of the Jeffrey Quay family.)

By the 1920s, most of the basswood trees were gone. Tin and glass vials replaced wooden pillboxes, signaling the end of a prosperous industry. Here, Arthur Quay, a direct descendant of early entrepreneurs, demonstrates how to use a drawknife and shave horse to produce the thin strips. The manufacturing of pillboxes is now considered a lost art. (Courtesy of Knox Historical Society.)

The hamlet of Knoxville was known for its main street, which was 100 feet wide. Revolutionary War soldiers drilled on the broad thoroughfare. Knoxville was home to sawmills, a tannery, a gristmill, a shoemaker, a blacksmith, a cabinetmaker, an undertaker, a schoolhouse, an academy, and small shops. The blackened beams from the forge of the blacksmith shop (pictured below) are visible to this day. (Courtesy of Knox Historical Society.)

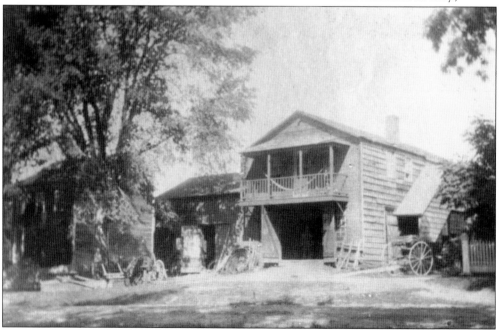

Young Margaret "Si" Stevens stands on the porch of her father's store and gas station in the old blacksmith shop. Stevens took over the business from her father and pumped gas, rain or shine, for decades. When the Mobil Corporation required her to install a canopy and lighted sign, she refused to comply. She stated that the "improvements" were too expensive and unnecessary in a small town. (Courtesy of Robert Stevens.)

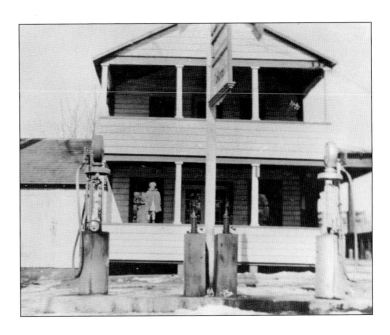

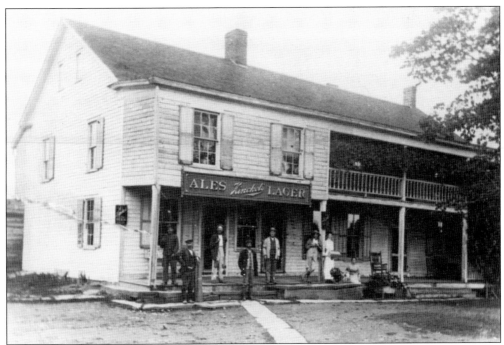

In the 1850s, the Plank Road Association constructed a plank road between Albany and Schoharie. Fees were collected at a tollbooth for the upkeep of the road. Defeated by high maintenance costs and the coming railroad, the association disbanded in 1867. The Township Hotel (pictured), in East Township, was a wayside inn along the road. Township Tavern (as it is now known), on present-day Route 146, still caters to the hungry and thirsty. (Courtesy of Knox Historical Society.)

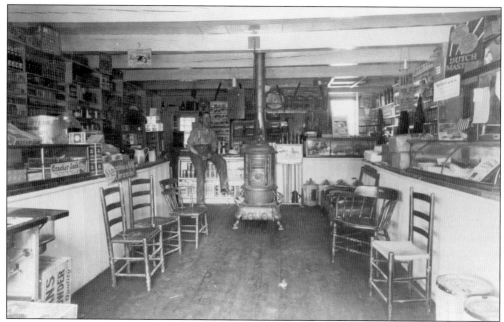

The southwest corner of Knox dips into the hamlet of West Berne. The town line passed through the store of Fred Posson, shown sitting on his counter. Customers stood in the town of Knox and warmed their hands in the town of Berne. Posson, who lived next door, passed from Knox into Berne and back into Knox on his way to work each day. (Courtesy of Berne Historical Society.)

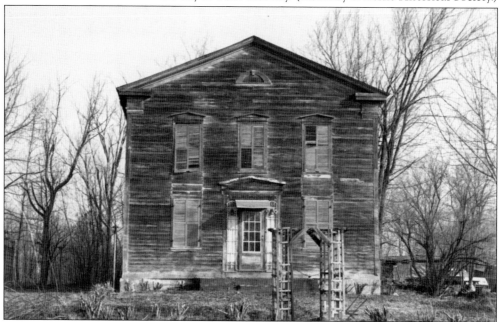

Lee's Corner was a small hamlet near the intersection of Church and Knox Cave Roads. It had a one-room schoolhouse, post office, cemetery, racetrack, shop, and church. The school and the church (pictured) have been converted into private residences. The well-tended, shady cemetery remains as homage to the Lees, the Gages, and other families who once lived in Knox. (Courtesy of Knox Historical Society.)

The one-room school was often the center of community life. Families arrived by lantern light to attend Christmas programs. Students were on their best behavior at spelling bees and graduation ceremonies. As the small districts joined the Berne-Knox Central system, schoolhouses found second lives as residences, fire stations, farm buildings, garages, or museums. School No. 4, shown here, became tenant housing on a farm. (Courtesy of Timothy J. Albright.)

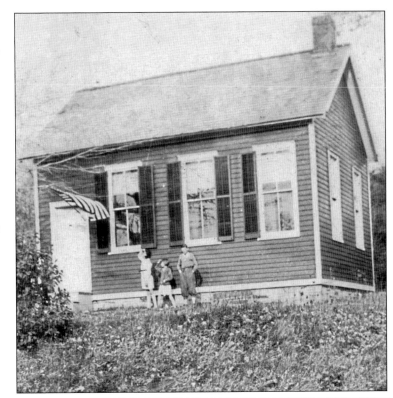

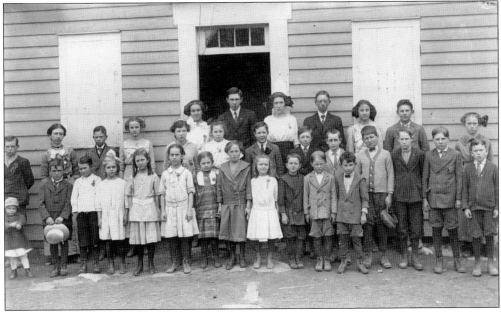

School No. 3 was located at the intersection of Pleasant Valley and Taber Roads. This part of town had the unfortunate name of Skunk's Misery. Local tradition says the name came from someone's cruel mistreatment of a skunk. After the local district joined Berne-Knox Central in 1932, the schoolhouse was moved to another part of Knox and turned into a dwelling. (Courtesy of the E.J. Hogan Collection.)

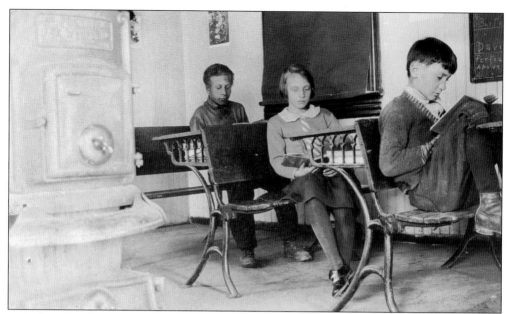

One chilly day, Marshall Warner (left), Beulah Ketcham (center), and Bill Sagendorf studied near the wood stove at Knox District School No. 5 on Ketcham Road. The one-room schoolhouse, now part of the Emma Treadwell Thacher Nature Center, was restored by the Kiwanis Club of the Helderbergs. It is the only building in Knox in the National Register of Historic Places. (Courtesy of Daniel Driscoll.)

Knoxville Academy, pictured on a souvenir spoon, was originally a Masonic Lodge. In the mid-1800s, it was a highly respected secondary school, attracting students from surrounding cities and abroad. The academy prepared students for teaching, business, or higher education. After the establishment of state-run normal (teacher-training) schools, the academy closed its doors. The building is now a private dwelling on Berne-Altamont Road. (Courtesy of Knox Historical Society.)

Frieda Saddlemire (left) began teaching in a one-room schoolhouse in the Rotterdam area and went on to gain national recognition as a leader in elementary education. For nearly 40 years as Knox town historian, she helped people discover their heritages. Saddlemire loved introducing young children to the wonders of nature and was a dynamic teacher at the Heldeberg Workshop Adventures in Learning program. (Courtesy of Berne Historical Society.)

In 1909, the Stafford and Burns families gathered at the homestead on Bozenkill Road. Although the Staffords had lived in Knox for over a century, younger family members felt the pinch of unemployment and moved away to find jobs. Some moved to Schenectady to work at General Electric. Improved transportation allowed other Hilltowners to commute to jobs off the Hill. (Courtesy of Barry and Terry Schinnerer.)

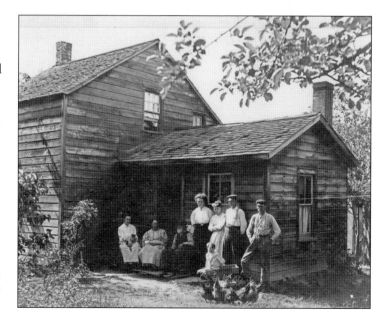

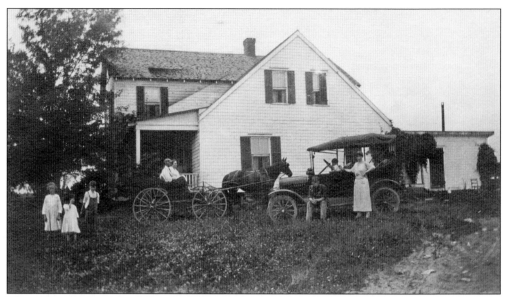

This photograph of the Whipple family farm, on Berne-Altamont Road, illustrates how the family stood with one foot in the 19th century and the other foot in the 20th. The coming of the automobile meant that people could find employment beyond the Hilltowns, and the close-knit villages gave way to a centralized school system, shopping centers, and travel opportunities hardly dreamed of just a few years before. (Courtesy of Henry A. Whipple.)

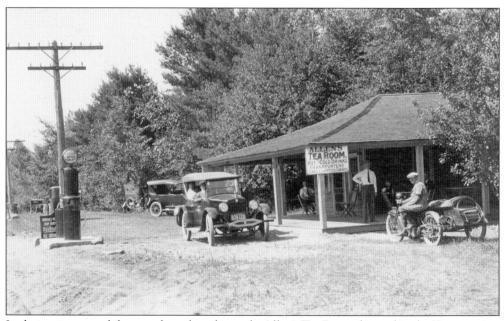

In their new automobiles, people took to the roads. Allen's Tea Room, located in the Knox section of West Berne, was a welcome stop for travelers crossing the Helderbergs. The Allens offered hot and cold drinks, frankfurters, candy, ice cream, and, of course, gasoline. Fox Creek runs just behind the building, and subsequent owners called this establishment the Foxenkill Lodge. (Courtesy of the E.J. Hogan Collection.)

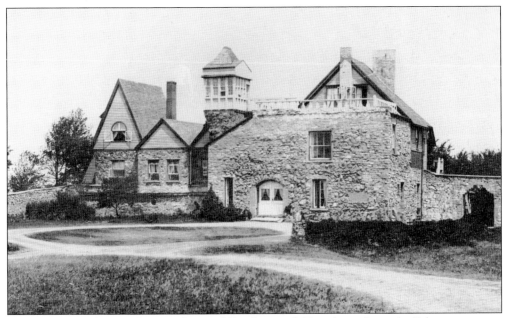

Edward R. Cassidy, an Albany architect, fell in love with French castles and a Belgian countess. In 1891, he built a French chateau on Old Stage Road in Knox. Cassidy Castle, made of Oriskany sandstone, featured a turret and Norman arch. Edward and Helene (as the countess was known in Knox) lived there until their marriage ended in 1898. (Courtesy of Knox Historical Society.)

Harriet Christie and Lucy Jones created a summer camp at Cassidy Castle in the summer of 1899. The Young Woman's Summer Camp offered rest and recreation to self-supporting young women of Albany. Campers took the train from Albany to Altamont and then came by horse-drawn wagon up the hill to Knox. The young ladies delighted in the fresh air and rural surroundings. (Courtesy of Knox Historical Society.)

Campers at the Young Woman's Summer Camp enjoyed hayrides, picnics, boating at Thompson's Lake, and day trips to the Indian Ladder on the Helderberg Escarpment. Over the years, rustic wooden ladders replaced the original notched trees. These intrepid campers prevailed over their long skirts, jackets, and feathered hats to make the ascent; the reward was a breathtaking view of three states—New York, Vermont, and Massachusetts. (Courtesy of Knox Historical Society.)

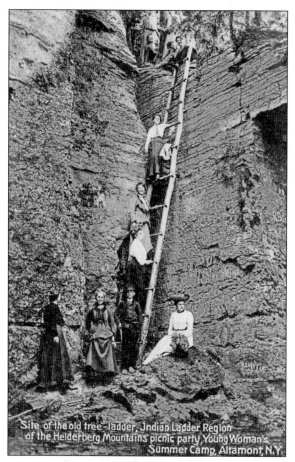

Site of the old tree-ladder, Indian Ladder Region of the Helderberg Mountains picnic party, Young Woman's Summer Camp, Altamont, N.Y.

After an exciting week in the country, the young women said "farewell" and headed back to the city. Around 1910, the YWCA ran the camp, and in 1929, the Salvation Army took ownership. By 1949, Cassidy Castle was in ruins and burned while being demolished. In 1957, the Boys and Girls Clubs of Schenectady established Camp Lovejoy on the property. (Courtesy of Knox Historical Society.)

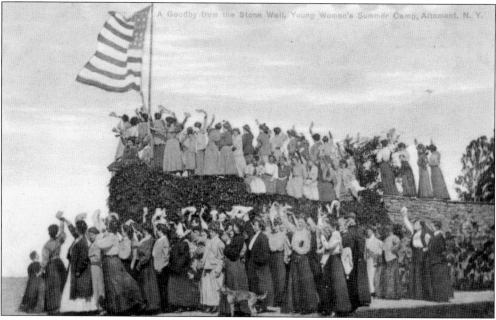

A Goodby from the Stone Wall, Young Women's Summer Camp, Altamont, N. Y.

In 1927, Lesley Brower saw opportunity in the growing tourist trade and opened a tea house in the former home of Merriman Nashold, a local inventor and wheelwright. Making a play on Nashold's first name, Brower called her business Merrymen's Tea House. She used old wagon wheels from the yard to fashion hanging signs with little "merry men" to guide visitors to the establishment. (Courtesy of Knox Historical Society.)

Merrymen's Tea House
Knox, N. Y.

Diners traveled from Schenectady and Albany to the quaint tea house furnished with antiques. Brower based her menu on what was available in her vegetable garden and at local farms. In 1939, the tearoom received national recognition with this review in the Duncan Hines book *Adventures in Good Eating*: "Excellent food, featuring homegrown fruits and vegetables, makes this place one to be recommended." (Courtesy of the E.J. Hogan Collection.)

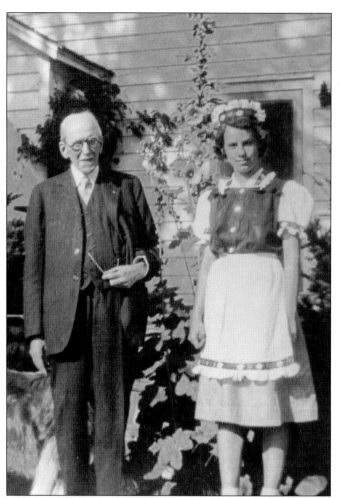

Ogden Brouwer stands outside his daughter Lesley's tea house with waitress Nellie Saddlemire (in her Tyrolean peasant costume). Unfortunately, hard work and excellent reviews could not compete with gas shortages during World War II. Frequently active in town affairs, Lesley Brower chaired the committee to establish a fire department in Knox. The tea house buildings burned to the ground in 1949. (Courtesy of Knox Historical Society.)

When Merrymen's Tea House closed, Knox lost a valued employer. Elizabeth Stevens, one of the waitresses, is shown here (with long hair, in the foreground) at a square dance in Schoolhouse No. 6, which later became the fire station in the hamlet of Knox. Stevens is dancing with her parents, Pearl (center) and Lucius, as Daniel Webster "Web" Stevens calls out "Circle left!" (Courtesy of Elizabeth Stevens.)

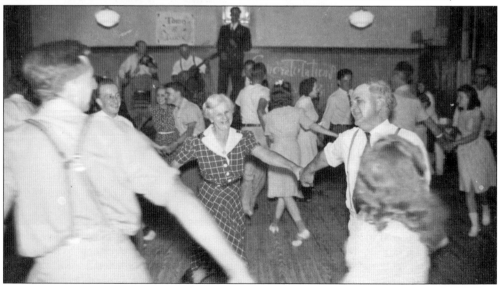

Due to its unique geological makeup, Knox is home to several caves, thought to be connected by a vast network of underground passages. The caves inspired legends of buried treasure and Native American artifacts. In 1933, D.C. Robinson capitalized on the natural attraction, fabricated a few tales of his own, and opened Knox Cave to tourists. (Courtesy of Knox Historical Society.)

KNOX CAVE COMPANY

PRESENTS

MYSTIC SPLENDOR OF THOUSANDS OF YEARS PAST

SEE AND MARVEL AT

Natures Hidden Beauty

AT

"KNOX CAVE"

NEAR

KNOX, N. Y.

Adventurers took wooden stairs down to the cave entrance and to passages that extended far underground. As it grew in popularity, Knox Cave attracted cavers from around the country. Geologists were eager to explore the karst formations and waterways. On some weekends, as many as 1,000 people took the guided tour. (Courtesy of Knox Historical Society.)

The First Pit, Big Room, Fish Pond, and Alabaster Room are some of the areas of Knox Cave. The Gunbarrel, as its name suggests, is a very narrow 50-foot-long passage through which the nimble, the brave, or the foolhardy would crawl. Michael Nardacci penned *The Knox Cave Overture* and wrote the following section to mimic the shape of the famous passage. (Courtesy of Knox Historical Society.)

THE GUNBARREL
By Michael Nardacci

the gunbarrel
is a narrow
passage
(fourteen
inches by
fourteen
inches and
almost fifty-
seven feet
long) what hell
it is to
crawl
through it
but if you
want to see
the cave be-
yond it it's the
only way to
go the only
trouble is
that once
you're through
it you're
not really
through be-
cause back
through is
the
only
way
out.

124

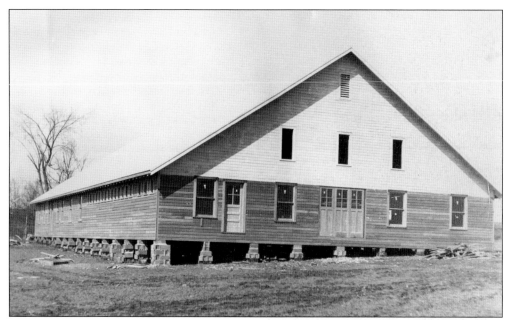

A couple from New York City held their wedding in the cave, with 160 guests celebrating in helmets and headlamps. Knox Cave was popular above the ground, too. People thronged to the roller rink—located topside, near the entrance to the cave—for speed skating contests, barn dances, record hops, ham radio meets, Boy Scout jamborees, and political meetings. Cool air from the cave provided natural air-conditioning. (Courtesy of Knox Historical Society.)

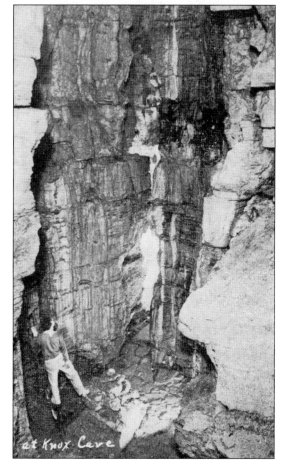

When tourism lagged, D.C. Robinson promoted the cave as a bomb shelter. In 1958, the property was closed to the public. The buildings burned, and the neglected cave proved dangerous for trespassers. Currently, the Knox Cave Preserve is privately owned by the Northeastern Cave Conservancy and is only open to experienced cavers. The New York Department of Environmental Conservation monitors the bat population. (Courtesy of John Elberfeld.)

At age two, a fearless Pauline Salisbury sat astride a National Guardsman's horse. She started college at age 16 and eventually became a successful business owner. In 1997, she put part of her family farm into a trust so that it could remain forever agricultural while feeding the hungry. The Patroon Land Farm produces tons of fresh, high-quality produce for the Regional Food Bank of Northeastern New York. (Courtesy of Pauline E. Williman.)

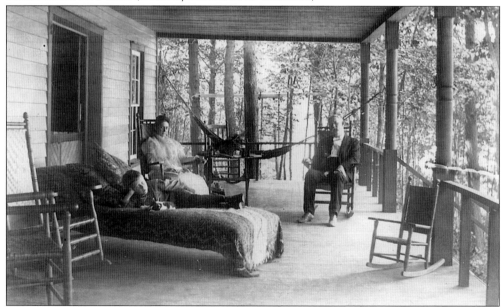

The Rev. John Gordon and family enjoyed their veranda on a summer's day in the early 1900s. His great-grandson Alexander Gordon operates a sustainable grass-fed beef and hay farm in Knox. Fifth-generation Hilltowner Sarah Avery Gordon (Alexander's daughter) has taken agriculture into the 21st century. She is the founder of Heldeberg Market and FarmieMarket, an online farmers' market that connects consumers with small family farms. (Courtesy of the Gordon family.)

A couple from New York City held their wedding in the cave, with 160 guests celebrating in helmets and headlamps. Knox Cave was popular above the ground, too. People thronged to the roller rink—located topside, near the entrance to the cave—for speed skating contests, barn dances, record hops, ham radio meets, Boy Scout jamborees, and political meetings. Cool air from the cave provided natural air-conditioning. (Courtesy of Knox Historical Society.)

When tourism lagged, D.C. Robinson promoted the cave as a bomb shelter. In 1958, the property was closed to the public. The buildings burned, and the neglected cave proved dangerous for trespassers. Currently, the Knox Cave Preserve is privately owned by the Northeastern Cave Conservancy and is only open to experienced cavers. The New York Department of Environmental Conservation monitors the bat population. (Courtesy of John Elberfeld.)

At age two, a fearless Pauline Salisbury sat astride a National Guardsman's horse. She started college at age 16 and eventually became a successful business owner. In 1997, she put part of her family farm into a trust so that it could remain forever agricultural while feeding the hungry. The Patroon Land Farm produces tons of fresh, high-quality produce for the Regional Food Bank of Northeastern New York. (Courtesy of Pauline E. Williman.)

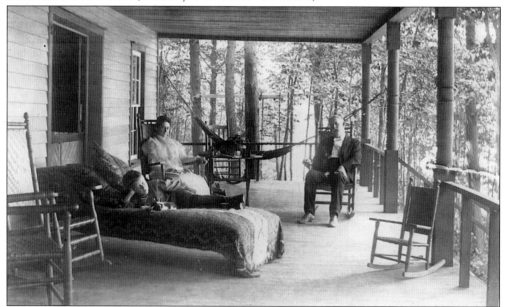

The Rev. John Gordon and family enjoyed their veranda on a summer's day in the early 1900s. His great-grandson Alexander Gordon operates a sustainable grass-fed beef and hay farm in Knox. Fifth-generation Hilltowner Sarah Avery Gordon (Alexander's daughter) has taken agriculture into the 21st century. She is the founder of Heldeberg Market and FarmieMarket, an online farmers' market that connects consumers with small family farms. (Courtesy of the Gordon family.)

BIBLIOGRAPHY

Albright, Timothy J., and Laura A. Ten Eyck. *John Boyd Thacher State Park and the Indian Ladder Region*. Charleston, SC: Arcadia Publishing, 2011.

altamontenterprise.com

Berne Historical Society. *Our Heritage*. Cornwallville, NY: Hope Farm Press, 1977.

Blaisdell, Thomas H. *Town of Westerlo Then and Now*. Westerlo, NY: Westerlo Bicentennial Committee, 1976.

Donhardt, Gary L. *Indian Ladder: A History of Life in the Helderbergs*. Collierville, TN: Donhardt and Daughters, 2001.

Driscoll, Daniel A., and Lindsay N. Childs, ed. *Helderberg Escarpment Planning Guide: A Project of the Helderberg Escarpment Planning Committee, February 2002*. Slingerlands, NY: Albany County Land Conservancy, 2002.

Gregg, Arthur B. *Old Hellebergh: Scenes from Early Guilderland*. Albany, NY: Boyd Printing Company, 1997.

Howell, George Rogers, and Jonathan Tenney. *Bi-centennial History of Albany. History of the County of Albany, N.Y., from 1609 to 1886*. New York: W.W. Munsell & Co., 1886.

Knox Sesquicentennial Committee. *Knox, New York Sesquicentennial, 1822–1972*. Knox, NY, 1972.

Osterhout, Willard. *Life Along the Way: The Journey Continues*. Albany, NY: Spectra Graphics, 2007.

Rensselaerville Historical Society. *People Made It Happen Here: History of the Town of Rensselaerville ca. 1788–1950*. Rensselaerville, NY: self-published, 1977.

Stempel, Rudolph V. *Memories*. Berne, NY: Berne Public Library, 2011.

Torrance, Mary Fisher. *Old Rensselaerville*. Hannacroix, NY: Hillcrest Press, 1998.

www.albanyhilltowns.com

www.bernehistory.org

DISCOVER THOUSANDS OF LOCAL HISTORY BOOKS FEATURING MILLIONS OF VINTAGE IMAGES

Arcadia Publishing, the leading local history publisher in the United States, is committed to making history accessible and meaningful through publishing books that celebrate and preserve the heritage of America's people and places.

Find more books like this at
www.arcadiapublishing.com

Search for your hometown history, your old stomping grounds, and even your favorite sports team.